CW00541146

WOOLTON
THROUGH TIME
David Paul

AMBERLEY PUBLISHING

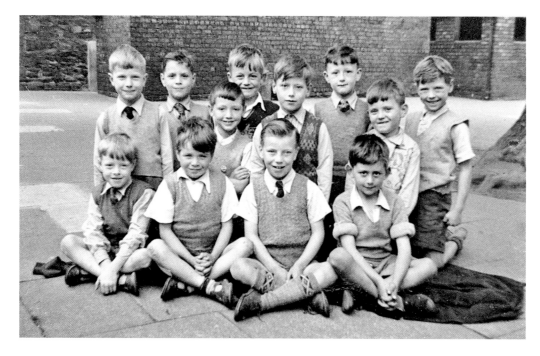

Much Woolton Infants' School – boys in top class, 1952.

For my classmates during those happy years
spent in Much Woolton School.

First published 2009

Amberley Publishing Plc
Cirencester Road, Chalford,
Stroud, Gloucestershire, GL6 8PE

www.amberley-books.com

Copyright © David Paul, 2009

The right of David Paul to be identified as the
Author of this work has been asserted in accordance
with the Copyrights, Designs and Patents Act 1988.

ISBN 978 1 84868 622 9

All rights reserved. No part of this book may be
reprinted or reproduced or utilised in any form
or by any electronic, mechanical or other means,
now known or hereafter invented, including
photocopying and recording, or in any information
storage or retrieval system, without the permission
in writing from the Publishers.

British Library Cataloguing in Publication Data.
A catalogue record for this book is available from
the British Library.

Typeset in 9.5pt on 12pt Celeste.
Typesetting by Amberley Publishing.
Printed in the UK.

Introduction

Much has been written about the changes of land ownership in and around the ancient village of Much Woolton, and still more make reference to the changes in name that Woolton has seen since the time of the Domesday Survey. As early as 1188, the village was known as Ulventune, Uvetone or Wlvinton, and later, in 1341, Wolvinton, Wolveton or Wolfeton. The names Wolton and Wollouton are in evidence from 1345, and then Miche Wolleton from 1429.

In 1066, four manors are recorded in the area: Ulventune, which comprised two plough-lands and half a league of wood. The land was held by Uctred for the customary rent of 64d. Wibaldeslei, also having two plough-lands, was held by Ulbert, who also paid the princely sum of 64d to farm the land. The other two manors, known as Uvetone, had one plough-land and were held by two thegns.

In 1338, the Hospitallers established a camera at Woolton, and the estate, including 50 acres of land, 5 acres of meadow and a water-mill, remained under their jurisdiction until the English branch of the Hospitallers was suppressed by Henry VIII, who took the manor into the Crown's estates. In 1609, James I gave the land to George Salter and John Williams as part payment of an earlier loan. Shortly afterwards, the land was transferred to the Earl of Derby.

The farming and upkeep of the lands remained much the same over the following centuries, although the lands changed owners on a number of occasions. It was not until the advent of the Industrial Revolution, and the burgeoning growth of the nearby town of Liverpool, that significant changes began to happen in the village.

Many of the changes that occurred in the village were due to the hand of James Rose, a local man born in 1783. He changed what has been described as barren heathland into cultivated farmland and parkland. He also built a windmill, and later, a mill house. Amongst his other business interests, James Rose was a quarry owner and built some fine sandstone mansions in the village, notably Beechwood and Rosemount. He was also instrumental in the building of Church Road, Rose Street and Rose Brow, which is on the edge of the village. James Rose is buried in St Peter's churchyard.

In 1811, the population of the village is recorded as being 671, but, largely due to the efforts of James Rose, that figure was due to rise. Woolton was viewed as a desirable place to live by many of Liverpool's wealthy businessmen and ship owners; not only did they moved their families to the village, they also brought in their wake large numbers of domestic staff and skilled craftsmen to augment the workforce already employed on the farms and in the quarries. By 1851, the population had risen to 3,699, a massive increase in just fifty years. However, there were other contributory factors that led to the rise in population. During that period, there was a significant influx of immigrants from Ireland due, in part, to the famine in that country.

Churches began to establish a presence in the village. The first Roman Catholic Church of St Mary was opened in Watergate Lane in 1765. Later, when James Rose built Church Road, the Anglican Church of St Peter was consecrated in 1826, and then, in 1834, a Wesleyan chapel was built. However, because of the continuing rise in population in Woolton, a new and larger cruciform church was built in 1860, and the new Church of St Mary was opened. Then, in 1864-5, the Wesleyans moved to their new Church of St James in High Street, which is where a new Congregational church was also built. The foundation stone of the new and greatly enlarged Anglican church was laid in 1886, and the church was consecrated the following year. Like most of the other prominent buildings in Woolton, the church was built of local sandstone.

During this major period of change, children from the village continued to be educated at the old school in School Lane. A second school building, opened in 1823, gave additional provision in the village. In 1848, another school building was opened, thus making the old school in School Lane redundant.

The topography of Woolton has changed over the years due to many factors: employment, schooling, trade, religious worship, etc., so the reader is now invited to peruse the contrasts on the following pages and enjoy discovering how Woolton has changed over the years.

David Paul
Woolton, September 2009

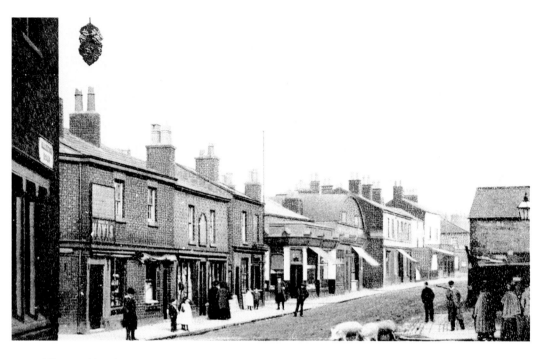

Allerton Road

At the turn of the last century, it was not uncommon to see pigs trotting down Allerton Road, but it's been a long time now since this sight was seen.

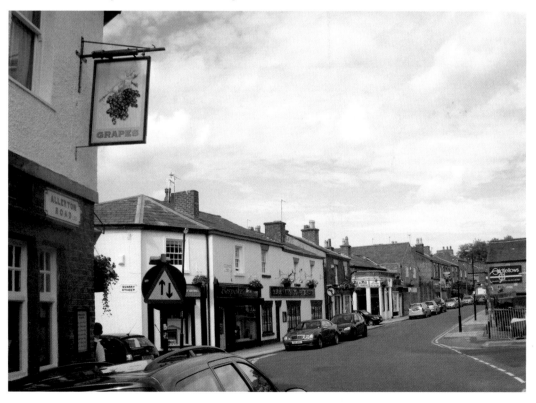

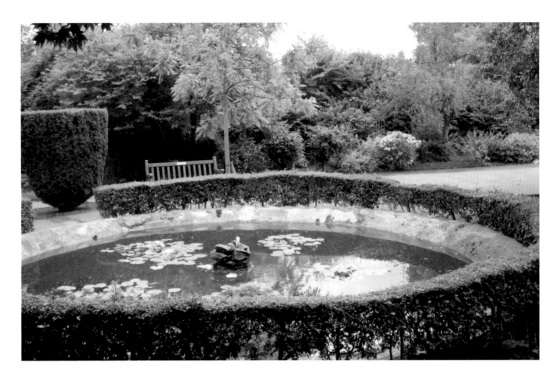

Walled Garden in Woolton Woods

Woolton achieved much success in the 2002 Britain in Bloom competition. It was in that year that the Walled Garden gained a BALI award, thus recognising the high standards of maintenance in the garden. Shortly afterwards, in 2004, the garden won the prestigious Anne Farmer Trophy for Walled Gardens. The garden continues to attract many visitors.

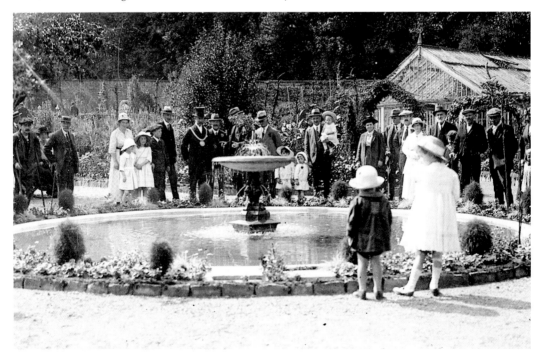

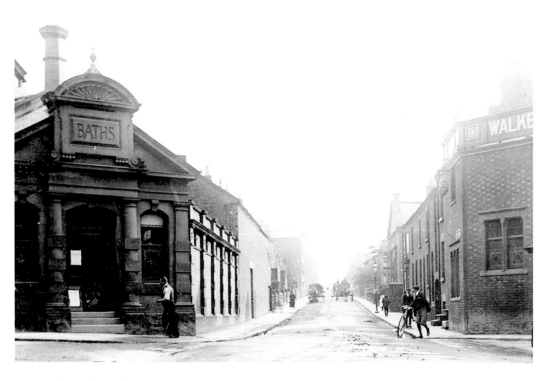

Swimming Baths

Woolton Baths, a graceful Victorian edifice built of local sandstone in 1893, was 'home' to the Woolton Swim Club until the 1930s. During the Second World War, the baths were used as a fire station. Fortunately, following the cessation of hostilities, the baths were restored in order to serve their original purpose.

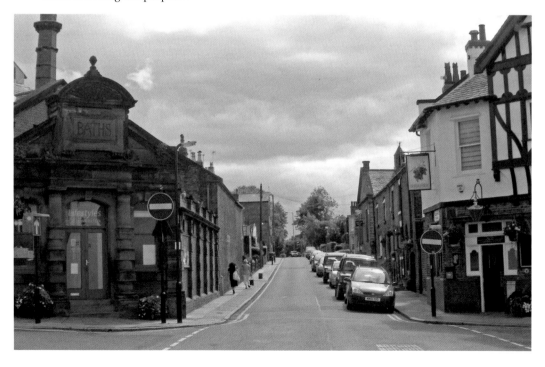

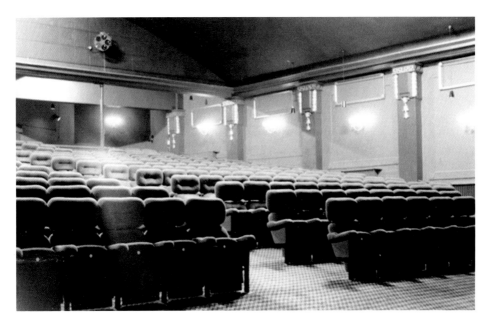

Inside Woolton Cinema

When the cinema was first built in 1927, it had a seating capacity in excess of 800, which included a number of wooden benches. When 'movies' were introduced in the 1930s, the screen had to be brought forward so that the sound system could be installed. This resulted in the loss of some of the cinema's seating availability.

The cinema survived the intense bombing that Liverpool was subjected to during the Second World War, and remained opened throughout that dark period. On 22 September 1958, there was a major fire at the cinema, which resulted in closure whilst extensive refurbishment work was carried out. The seating capacity was again reduced, this time to less than 600 seats. Then, in the 1980s, when Cheshire County Cinemas owned the cinema, a new wall-to-wall screen proscenium was installed, together with new carpeting and 256 luxury Pullman seats. The cinema is still one of the most comfortable in the region!

The inset shows Dave Swindell, who, until his recent death, was projectionist and stalwart at Woolton cinema for many years.

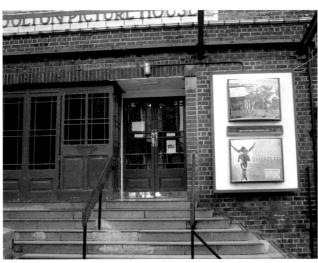
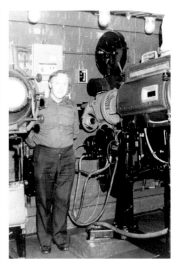

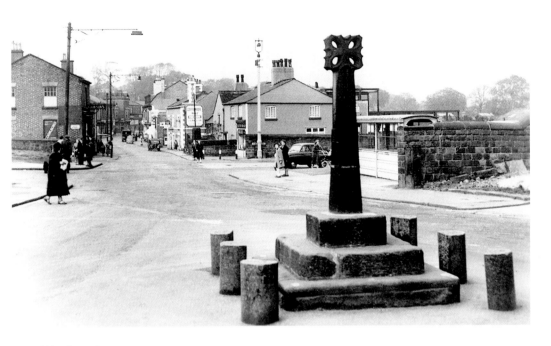

Woolton Cross

It is believed that Woolton Cross, which is perhaps the oldest man-made object of any significance in the village, was erected somewhere in the region of 1350, but there is no definitive record of the exact date. The cross marked the northern boundary of the village – a similar one, Hunts Cross, marking the southern boundary. Many years ago, at an unknown date, the cross was broken; but, in 1913, when Woolton was incorporated into the City of Liverpool, Arthur S. Mather was commissioned to restore the cross in celebration of that event.

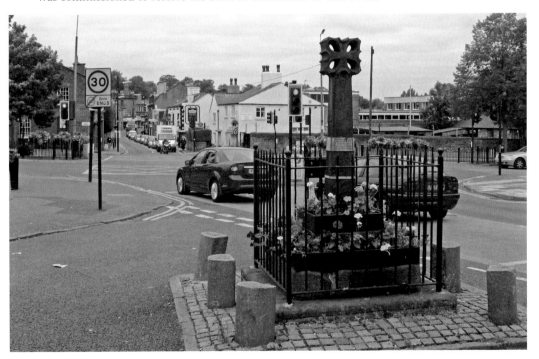

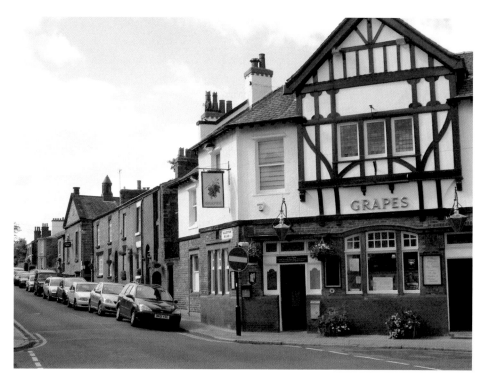

The Grapes

The Grapes has stood opposite Woolton Baths for as long as anyone can remember. It's still a very popular pub in the centre of the village, lying as it does at the crossroads between Allerton Road and Quarry Street.

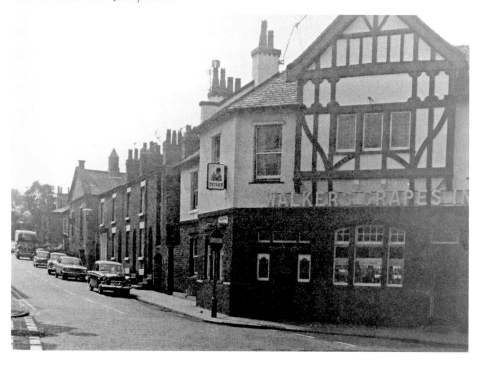

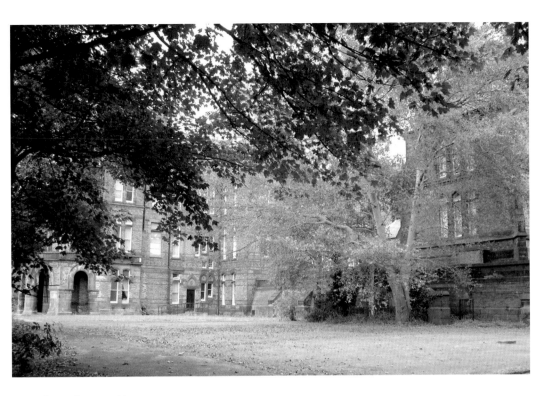

Convalescent Home

Surplus funds from the Liverpool Fund for the Relief of the Cotton Famine in 1862, enabled the Liverpool Convalescent Institution – as it was originally known – to be built. The building was primarily intended for patients who had been treated in Liverpool's hospitals.

Today, Woolton Manor Care Home is a care home with nursing. It is privately owned.

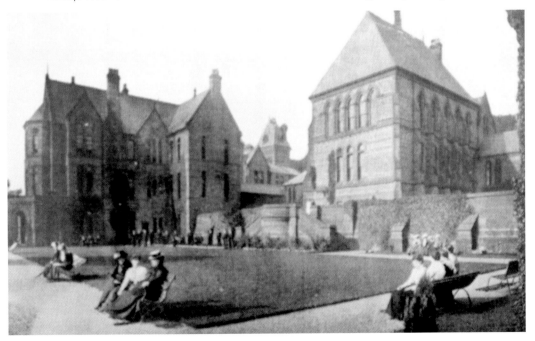

Rose Brow Looking Towards Cuckoo Lane

The quarrying of sandstone in and around Woolton, coupled with the wealth accrued from business and trade interests in the nearby city of Liverpool, meant that many prominent businessmen and quarry owners were resident in the village; some of the more illustrious residents being John Greenough, James Gore and James Rose. Indeed, sandstone from the quarry owned by James Rose was used in the infrastructure of Rose Brow, which still bears his name.

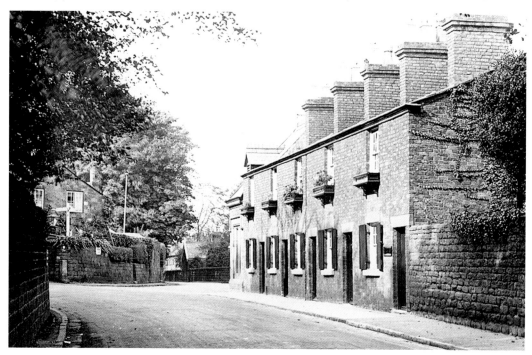

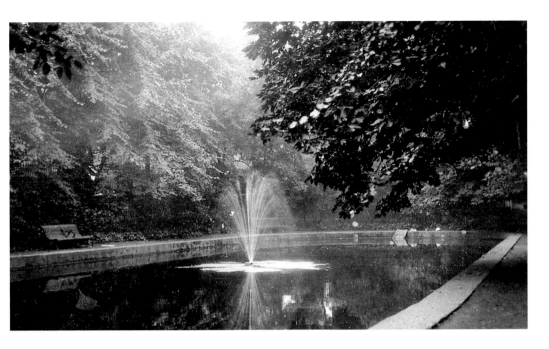

Lodes Pond with Fountain

The fountain in the centre of Lodes Pond was once a central feature and added attraction for the pond. But, in those days, well before the end of the nineteenth century, the pond and its 'shrubbery' were always a popular meeting place for the villagers of Woolton. Today, Lodes Pond helps to alleviate the parking problems in the village.

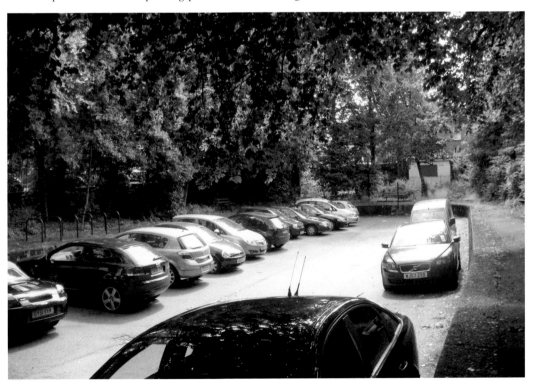

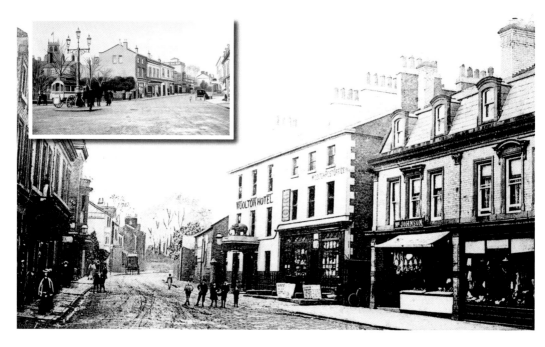

Looking Towards Acrefield Road

Acrefield Road, one of the main roads leading into and out of Woolton, carries far more traffic now than it did in bygone days. What does remain constant, however, is the fact that people still come into the village to make their daily purchases.

The photograph that is inset was taken from a little further down the road but still looks towards Acrefield Road.

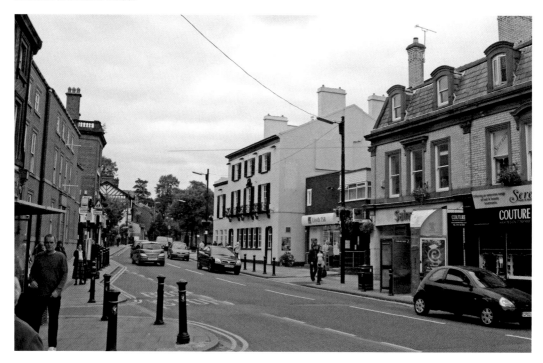

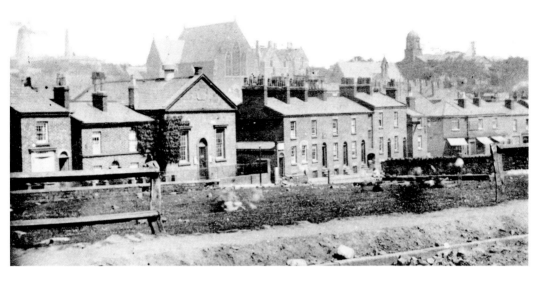

Wesleyan Chapel

The earlier photograph must have been taken somewhere between 1826 and 1886, because the dome of the first St Peter's church can clearly be seen towards the right, at the back of the shot. Also, Woolton's last windmill is still in evidence. The Wesleyan chapel, built in 1834 and seen in the foreground, is now Woolton Library.

There are now rows of buildings in front of the library, and the vista has changed quite significantly since the earlier photograph was taken; the buildings of St Mary's are still prominent, and the new St Peter's can also be seen in the background.

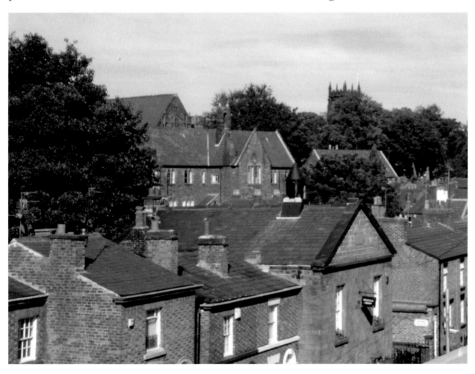

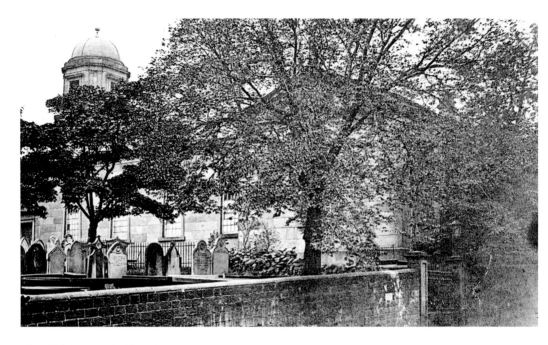

The Old St Peter's Church

With the increase in trade and industry in and around the village, there was a corresponding increase in the population, which in turn gave rise to the need for more social amenities, including a suitable place of worship. The first Church of St Peter, built from locally quarried sandstone and holding about 200 people, was consecrated in 1826; before that time, worshippers had to travel to the church in Childwall – a round trip of about six miles. Revd Robert Leicester was the church's first incumbent, serving the parish for forty-nine years. During his long incumbency he gave many gifts to the village, including the village's central street lamp and the drinking fountain at the bottom of Church Road. Again, because of an increase in the population of the village, it was deemed that a new and larger church must be built, and in 1886, the original Church of St Peter was replaced with the present church. However, the old church was dismantled, stone by stone, and rebuilt as the parish hall of St Cleopas in Mill Street.

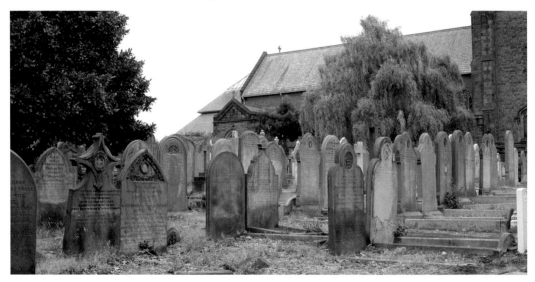

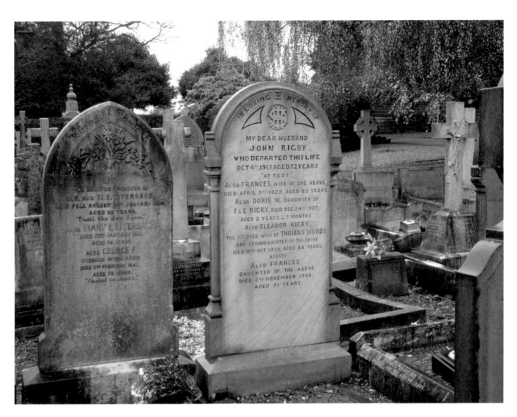

The Grave of Eleanor Rigby

In the churchyard of St Peter's Church is the grave of Eleanor Rigby, made famous through The Beatles song of the same name. The church hall is also where John Lennon and Paul McCartney first met, at the Woolton Parish Church garden fête. They also played here later as the Quarrymen.

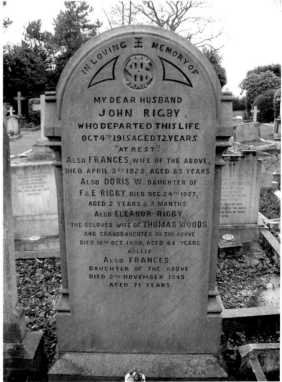

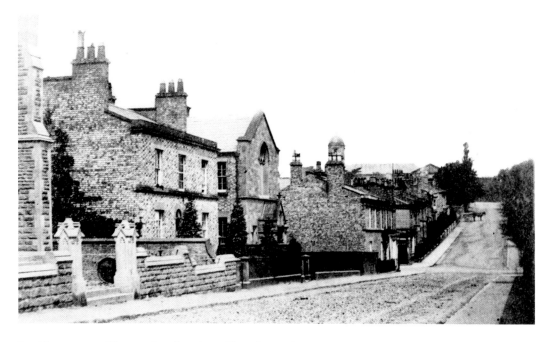

Looking across Allerton Road and up Church Road

The view is taken from Church Road South, looking towards Church Road. In the earlier photograph, the dome of the old St Peter's church can clearly be seen, indicating that the photograph was probably taken before the end of the nineteenth century – the church was dismantled, stone by stone, and rebuilt in the Toxteth area of Liverpool.

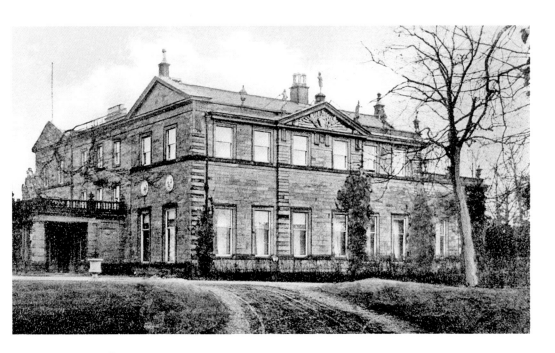

Woolton Hall

It's difficult to ascertain exactly when Woolton Hall became established as a grand manor house, but when William Brettargh died in 1609, he bequeathed what was termed 'a cottage' in Much Woolton. Sometime later, the Broughton family succeeded to his lands and, as early as 1700, the north side of the hall was described as a substantial, three-storey stone house. In 1704, Richard Molyneux became owner of the house and a substantial estate surrounding. When he married in the following year, he built the North Block of the Hall; in all probability, the stone being taken from a nearby quarry in Woolton Woods. Since that time, the hall has had a number of owners, including Nicholas Ashton, who made substantial changes to it. The building is now undergoing major renovation.

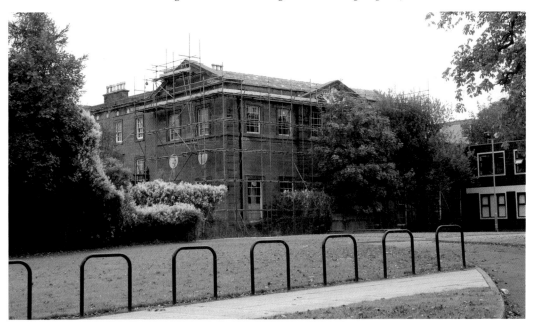

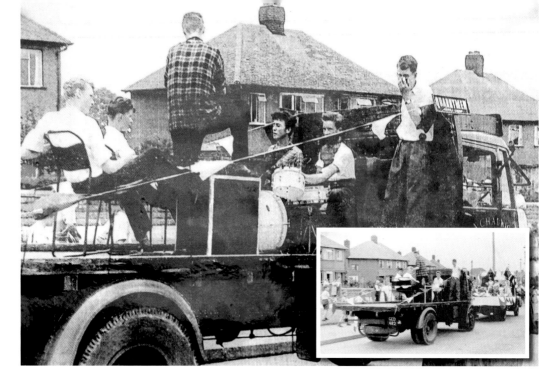

The Quarrymen

It was a bright, sunny afternoon on Saturday 6 July 1957 when the Band of the Cheshire Yeomanry led the annual procession around the village, which traditionally marked the start of St Peter's fête. On one of the floats, towards the back of the procession, was a skiffle group, The Quarrymen; they were scheduled to perform at the fête. Later, when the group – Rod Davis, Len Garry, Eric Griffiths, Colin Hanton, Pete Shotton and a young man called John Lennon – made their first appearance, which was on the church field, there was, amongst the audience, a certain Paul McCartney. Later that day, before the group's evening performance in the church hall, Ivan Vaughan, who sometimes played with the group, introduced his friend, Paul, to John Lennon. That meeting has been recognised as being 'almost certainly the most important meeting in popular music history'. Generally, the people and traffic passing along Kings Drive today are totally oblivious of that momentous parade.

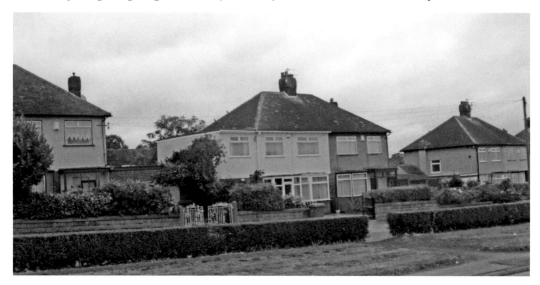

Woolton Conservative Club

Like so many other buildings in Woolton, the outward appearance of the conservative club in Woolton is much the same now as it has been for a number of years – perhaps a sign that some things remain constant in a changing world.

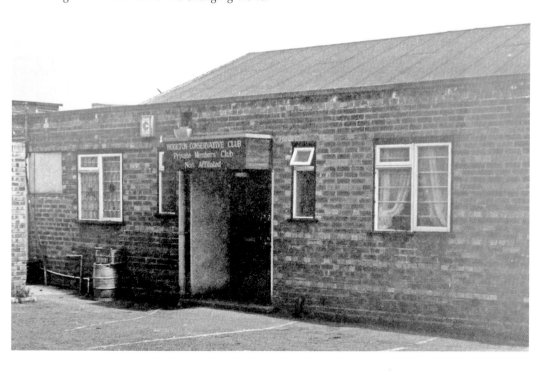

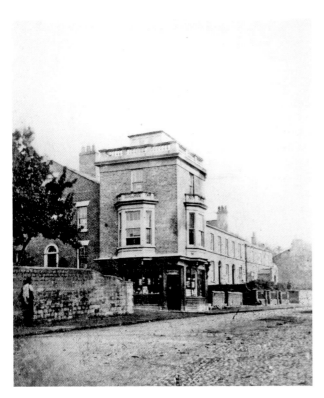

Bottom of Mason Street
The bottom of Mason Street, where it joins Acrefield Road, has seen many changes over the years. What is now a property owned by Allerton Glass was, for many years, the apothecary's.

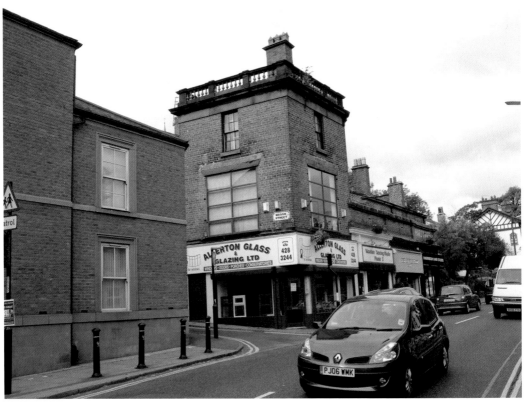

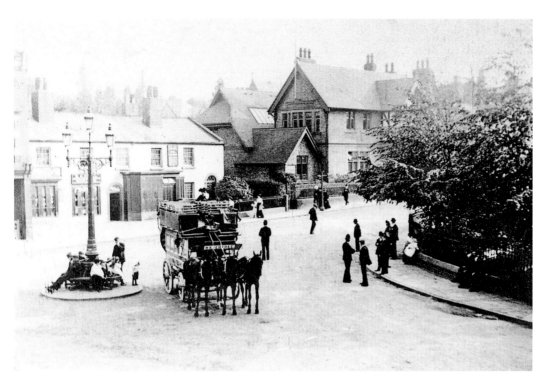

Stage near Lodes Pond

The horse-drawn omnibus had its starting point at Lodes Pond and then went on its way to Wavertree. Buses still pass through the village, but they're not horse-drawn now!

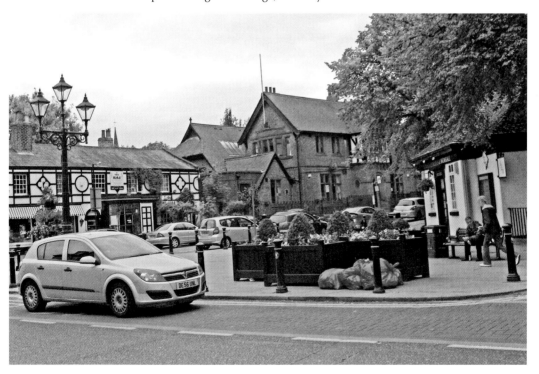

Looking from Woolton Wood to Church Road

Originally built in 1864-5 as a Wesleyan church, St James', in Woolton High Street, is now known as St James' United church (Methodist & United Reform). The trees have grown, just a little, since the earlier photograph was taken!

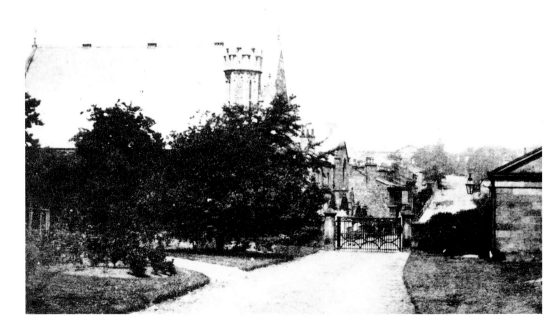

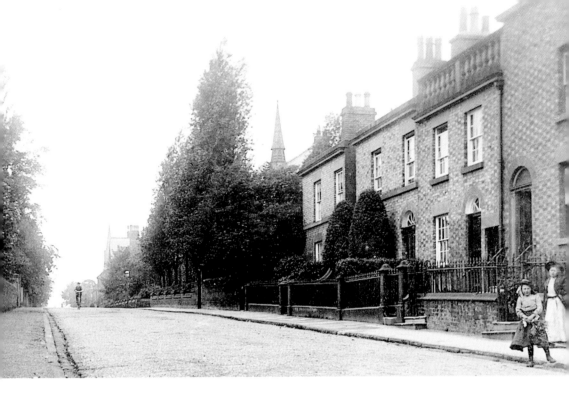

High Street

Running parallel with the perimeter of Woolton Wood, High Street has for many years been one of the main thoroughfares in Woolton. However, the volume of traffic now is somewhat greater than it was when these two young women were photographed.

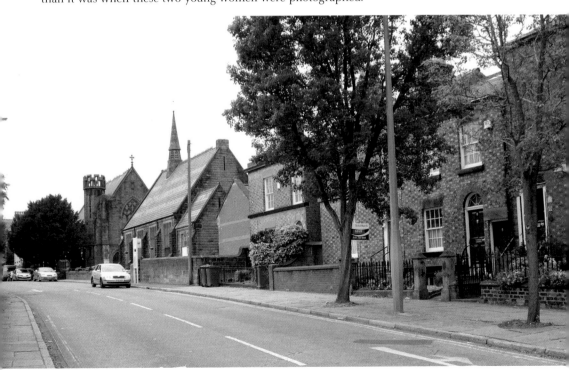

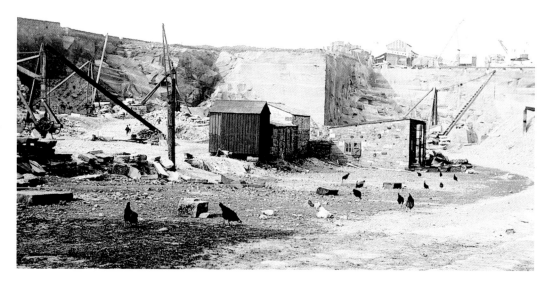

North Quarry

Sandstone quarries have been a feature in Woolton's landscape for centuries; there were quarries at Woolton Hill Road, School Lane and Quarry Street, to name but three. The sandstone was of a particularly good quality, and, because of this, was used to build many of the grand houses and mansions in and around the Woolton area. Most of the sandstone used in the building of Liverpool's Anglican cathedral was quarried at Woolton.

With the demise of quarrying in the north quarry, the area became a refuse tip. But, the refuse tip is no more, and the area has now been completely transformed into a smart, residential development.

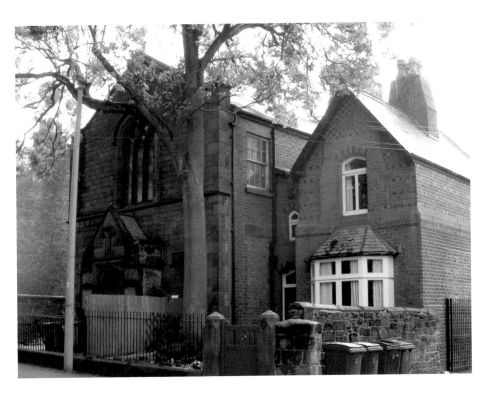

Much Woolton School – School Cottage
The head teacher of the school always lived in the schoolhouse, known as School Cottage, which was next to the infants' school.

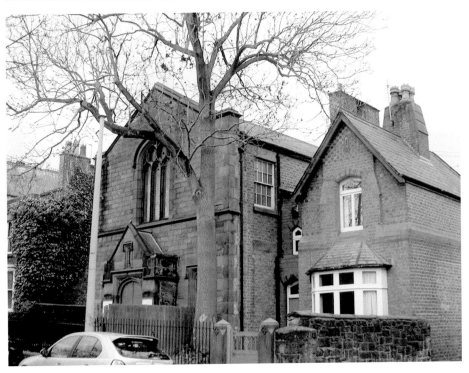

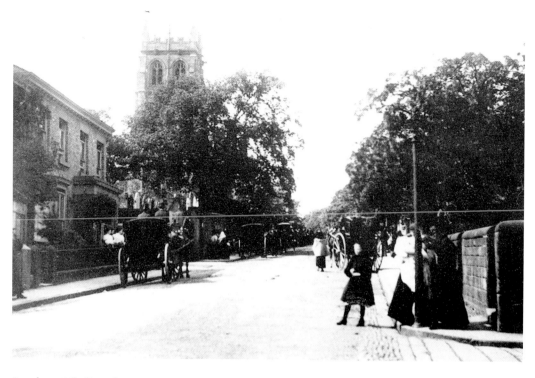

Sunday at St Peter's

The carriages that used to wait on Church Road to bring worshippers to St Peter's have now been replaced by today's chosen means of private transport, the motorcar.

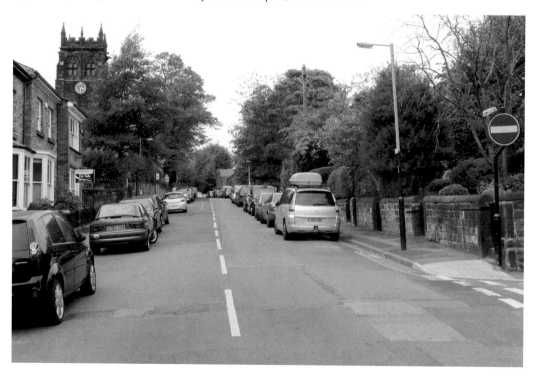

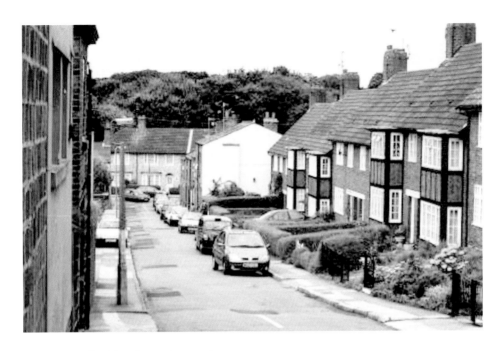

Rose Street looking from Quarry Street

In his early life, James Rose was a miller in the nearby village of Garston. Following his marriage, which considerably enhanced his financial status, he acquired land in Woolton and built a windmill. The venture proved to be profitable, so James Rose invested in more land, purchased sandstone quarries, and built a steam-mill close to the windmill and Mill House. But Rose's business ventures did not end there, and he built Rosemont and Beechwood – which subsequently became Archbishop's House. Rose Street and Rose Brow also bear the name of this prominent resident.

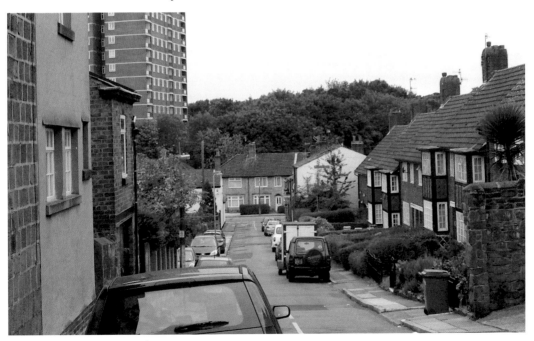

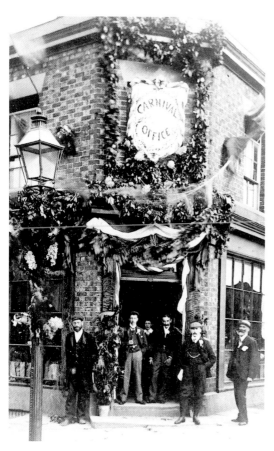

Wainwright's Shop
Wainwright's shop at the bottom of Church Road being used as the carnival office when the first photograph was taken *c.* 1900. Today, it is home to a solicitor's practice.

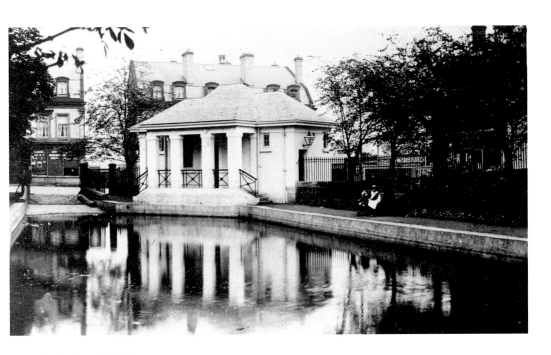

Lodes Pond Shelter

Lodes Pond, which is located at the junction of Church Road and Allerton Road, was drained in 1936, so the striking reflection of the ornamental shelter can no longer be seen and enjoyed. The pond is first shown on a map dating from 1768 and it has been suggested that, similar to other ponds which were in the area of Manor Road, Lodes Pond was originally a marl pit; it is known that marl was dug and used widely as a fertiliser in and around the area of Woolton.

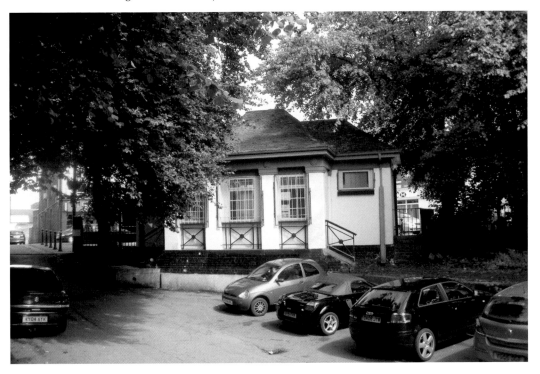

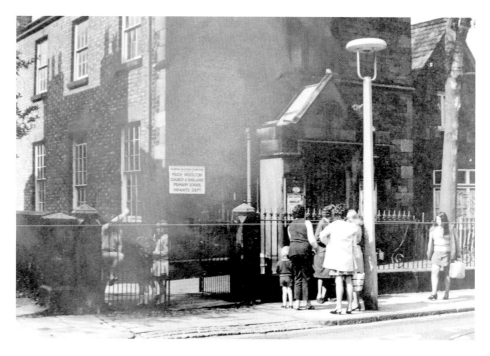

Much Woolton Infants' School

It is recorded that, in 1831, a grant of £300 was made to the National School in Much Woolton for 'enlargements'. In 1848, when building work was completed, the girls school was transferred to this building. In turn, the boys school was moved from the building in School Lane to the building 'up the hill' in Church Road. There have been some reorganisations in usage in the period since, but the fact remains that, for many, many years, St Peter's School has welcomed successive generations of Wooltonians.

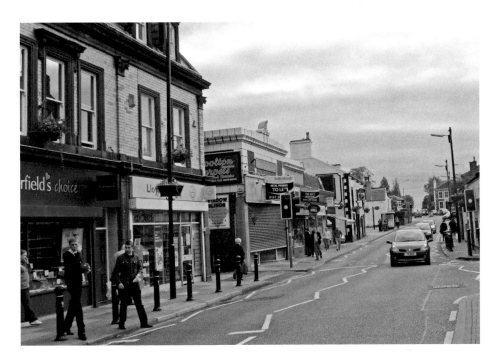

Woolton Street

If only we could time travel! The people featuring in the earlier photograph would doubtless find today's Woolton Street very, very different from the one with which they were familiar. Similarly, today's residents would see a very different Woolton Street from the one they know!

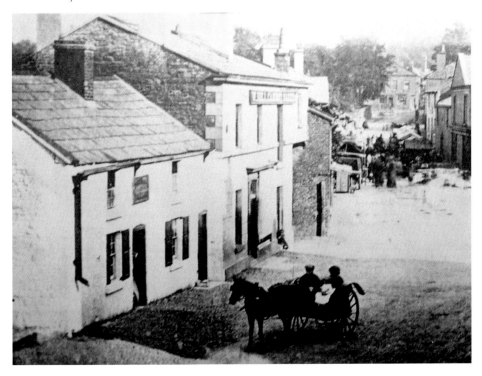

Woolton Wood
The shady paths through Woolton Woods still provide comfort and solace in today's busy world, much as they did in bygone days.

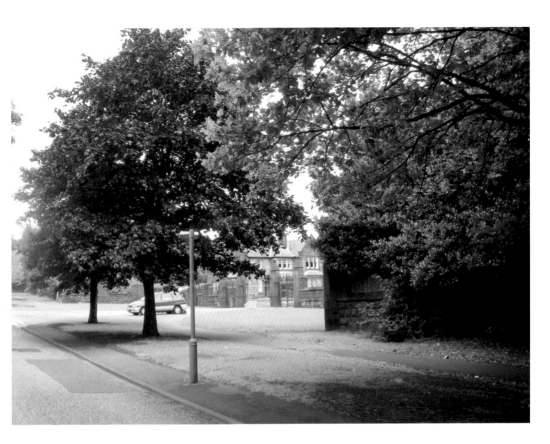

Springwood Avenue

Springwood Avenue was constructed in 1922, and the nearby cemetery was opened shortly afterwards. The cemetery at Springwood is still the last resting place for many Wooltonians.

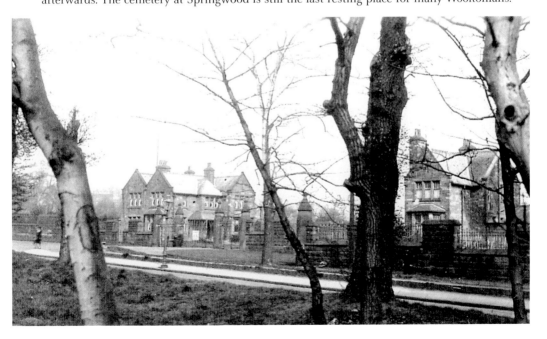

Houses along School Lane

School Lane is the home of Lancashire's oldest school, the building dating from the early seventeenth century. Further along the lane, there are groups of houses that were once home to many of the servants at Woolton Hall and still further along are some of the more recently built houses. These houses were built sometime after the village of Woolton was incorporated into the City of Liverpool. One significant change along the road is the introduction of 'speed bumps' – a sure sign of living in the twenty-first century!

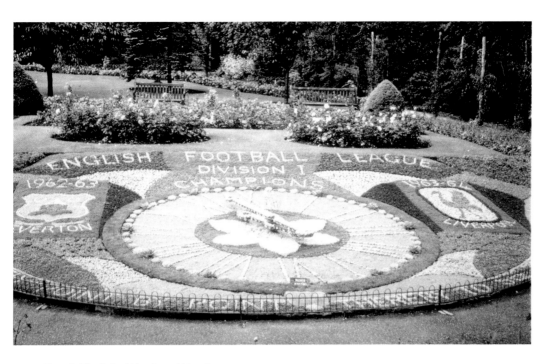

Floral Clock in Woolton Wood

The Floral Cuckoo Clock in the Old English Rose Garden in Woolton Wood is still one of the most popular attractions of the wood.

In 1871, the Gaskell family was resident at Woolton Wood, and it was some years later, in 1927, that the family of James Bellhouse Gaskell presented the Floral Cuckoo Clock to the people of Liverpool in memory of his long connection with Woolton Wood.

The walled garden, which is 'home' to the cuckoo clock, is, sadly, all that remains of the mansion owned by the Gaskells.

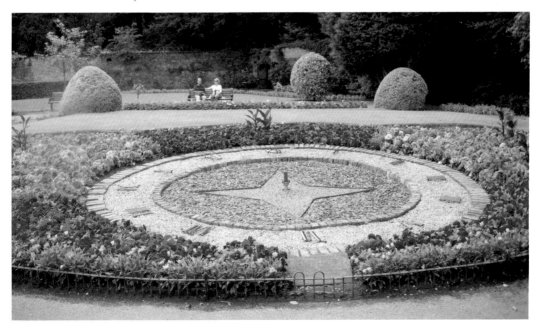

Looking towards Woolton from Woolton Wood

It was in 1917 that Col James P. Reynolds of Dove Park (Reynolds Park) purchased the 22-hectare estate known as Woolton Wood from the Gaskell family, the then owners of the estate. The entire estate was purchased for the princely sum of £12,000! Col Reynolds was the last private owner of the estate. Ultimately, he sold most of the wood to Liverpool Corporation, but, in acknowledgement of having lived for over fifty years in this most beautiful part of the city, declared that a 10-acre strip of land fronting Woolton Wood on the north-easterly side at High Street should be used as a recreation ground for local people, and still, on every day of the year, local residents enjoy his bequest. The inset shows the senior athletics team – they sometimes practiced on the strip of land in Woolton Wood.

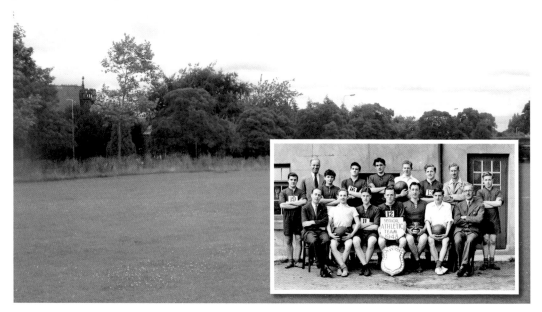

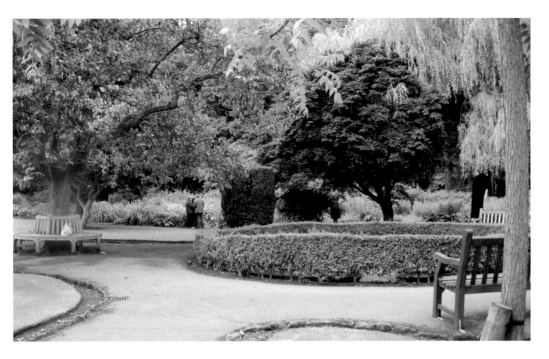

Fish-Pond in Woolton Wood

The walled garden, which is where the fish-pond is located, was, for many years, the kitchen garden of Woolton Hall. However, since that time, it has become, and remains, a place of rest and tranquillity for the folk of Woolton.

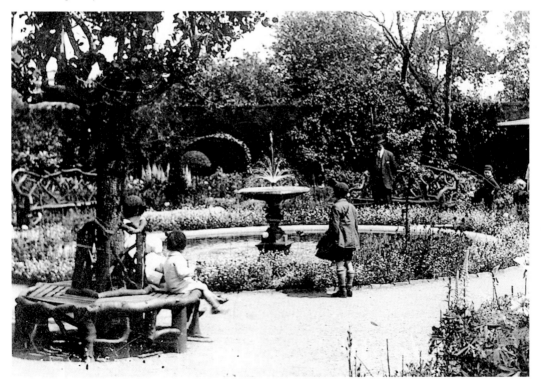

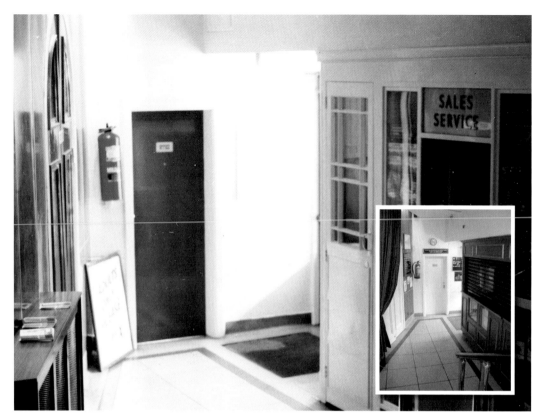

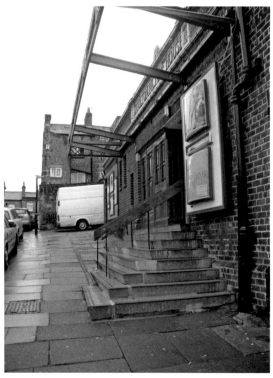

Foyer – Woolton Cinema

The Picture House, to give it its correct title, has long been known colloquially as 'The Woolton', the name being one of immense fondness rather than anything else, as the cinema has a special spot in the heart of all Wooltonians. But, there are other nicknames; John Lennon, on the frequent occasions when he visited the cinema, disparagingly referred to it as 'the bug'!

Opened on 26 December 1927, it is the oldest surviving cinema in Liverpool. Although the films being screened may have changed somewhat from those of earlier times, the foyer is much the same as it has been for many years.

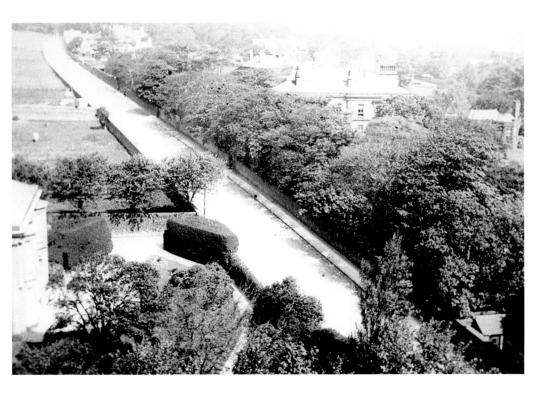

Looking up Church Road

The view looking from the top of the tower of St Peter's is very different now from when James Rose first built Church Road. It's difficult to see the road below amongst all of the foliage, but Rosemount on the far left and Beechwood on the right, both built by James Rose, can still be seen.

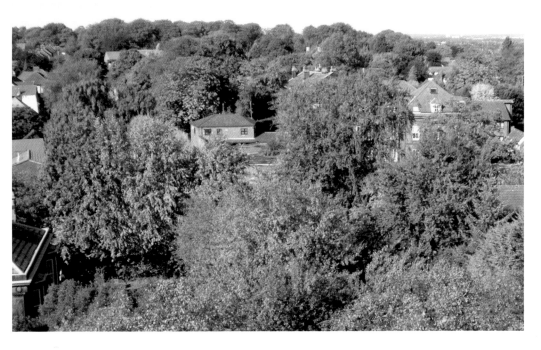

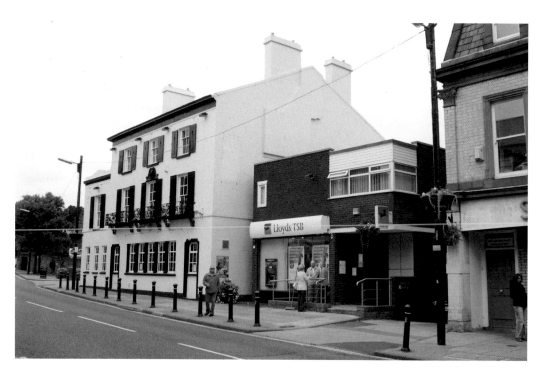

The Elephant Hotel

For many years, the Elephant Hotel has been one of the more popular 'watering holes' in Woolton. The hotel has seen many changes in the village, and has always sought to accommodate and reflect those changes. Indeed, currently, the hotel is undergoing another major refurbishment.

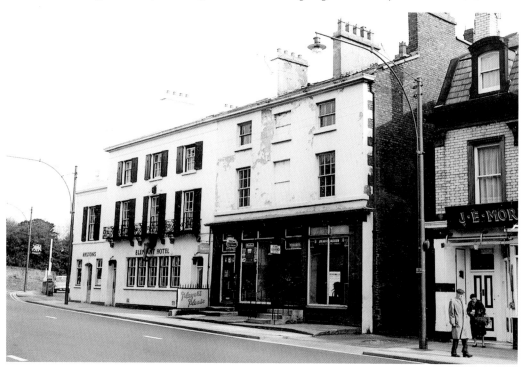

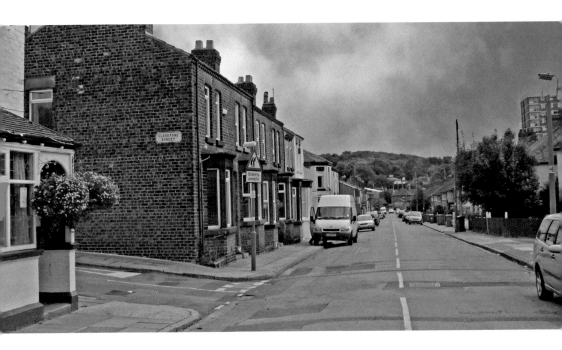

Vale Road

Vale Road, typical of so many residential roads in Woolton, was home to many families who worked in the factories and workplaces of Woolton. Before the turn of the last century, skilled workers were employed in the quarries, the gasworks and the Bear Brand factory, to name but a few of the many places offering gainful employment. The road was well served with shops and other social amenities, such as the Gardeners Arms – a popular pub then, as it still is now.

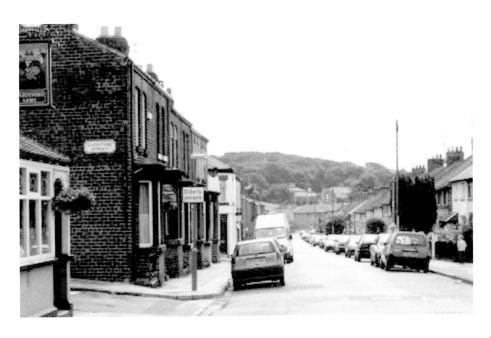

The Old Barn in School Lane

Over a thousand years ago, there was an Iron Age fort located on the top of Camp Hill. Since that time, Camp Hill has seen many changes. Sometime in the early seventeenth century, a school building was erected in the aptly named School Lane, which runs, in part, parallel to Camp Hill. Several lodges and grand houses were built along this road, giving easy access to Camp Hill and also the estate of Woolton Wood. Many of the houses have been retained and refurbished, as can be seen from the Old Barn along School Lane, which still bears testament to earlier times.

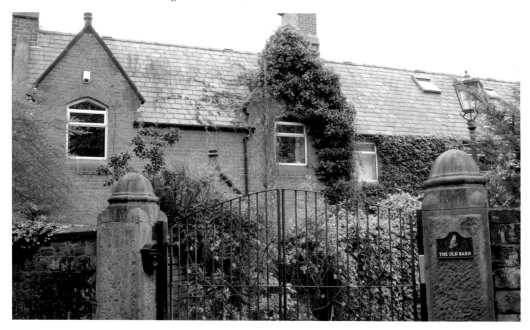

Mill Stile

Of the many quarries being worked in and around Woolton, it is the quarries situated between Quarry Street and Church Road that, perhaps, are most noted. The two quarries were separated by a public footpath, which is still known as Mill Stile – the mill being located in Church Road.

Although quarrying had started before 1870 to the north of the Mill Stile, it was not until 1905 that stone was excavated for the building of the Anglican cathedral in Liverpool. Sometime later, in 1934, the Marquis of Salisbury – then owner of the quarry – made a gift of the 6.5-acre quarry freehold to the Cathedral Committee, thus ensuring that the building of the cathedral would be completed to a uniform standard.

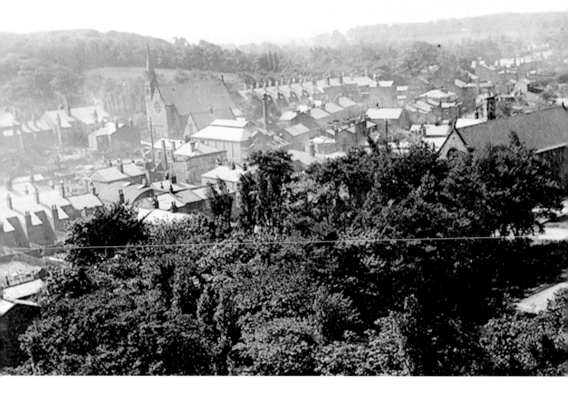

Looking out over the River Mersey

Looking out over the River Mersey from the top of the tower of St Peter's, the mountains of Wales can clearly be seen. In the centre left is the former Congregational church and, directly in front of it on both photos, the solid edifice of Woolton Baths.

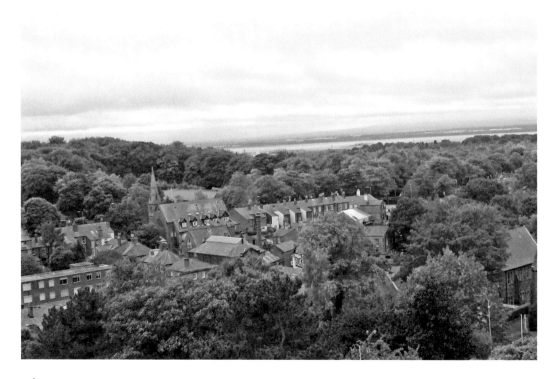

Woolton Windmill

It is believed that James Rose was born in or near to Woolton in 1783. In 1806, he married a lady of some considerable wealth – owning seven windmills in her own right. Although extensive, most of Rose's business interests were focused in and around Woolton, quarries and farmlands being two of his principal interests. After constructing Church Road, Rose built a mill in 1810. Later, in 1835, he revolutionised the mill by introducing steam power. Rose is widely acknowledged to have transformed the village from barren land into good farmland and parkland. When he died in 1860, the bells of St Peter's were tolled, continuously, for three days.

Little evidence of his mill remains today, but part of the perimeter wall can still be seen near to the Mill Stile. Beechwood, which Rose built and lived in for many years, is still standing, as is Rosemount, another of the fine sandstone houses that he built.

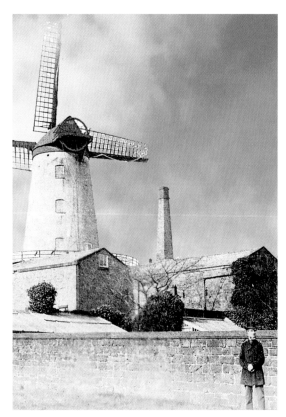

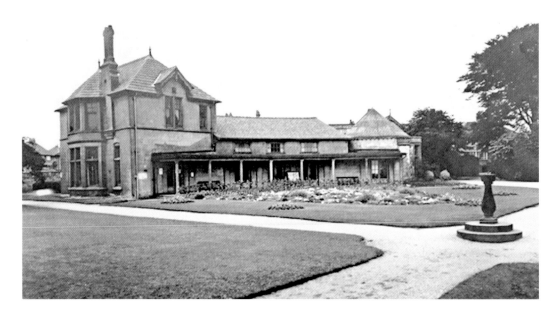

Reynolds Park

The original parkland, which is now known as Reynolds Park, provided common grazing for local people as a result of Enclosures Act 1805. Church Road, which lies adjacent to the park, was 'home' to many of Liverpool's great Victorians – people such as Samuel Weston, a Liverpool merchant; John Crosthwaite, a director of the Great Western Railway; and George Cope, whose wealth came from the tobacco trade. But perhaps James Reynolds is the best-known owner of the estate. He was a wealthy cotton broker in Liverpool and, in addition to owning Reynolds Park, also owned a castle in Wales and Levens Hall in Cumbria.

Since the mansion at Reynolds Park was destroyed by fire, the footprint has been redeveloped into a 'sheltered housing' accommodation, and is now known as Calvert Court.

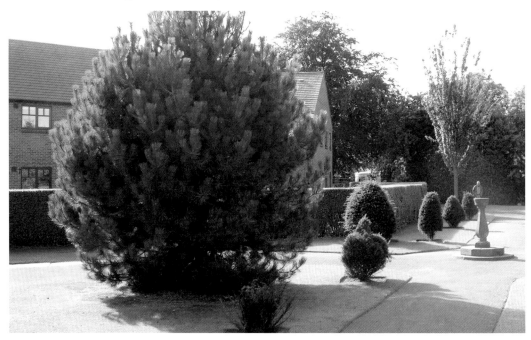

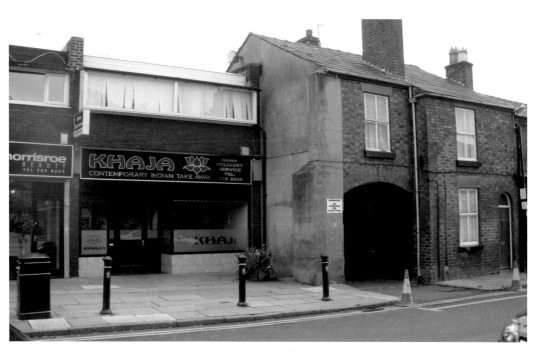

McKenzie's Garage

Much has changed in Allerton Road since R. N. McKenzie & Sons owned the garage bearing their name. The archway leading to the rear and the house next door are still there, but the garage has gone and been replaced by a block of modern shops.

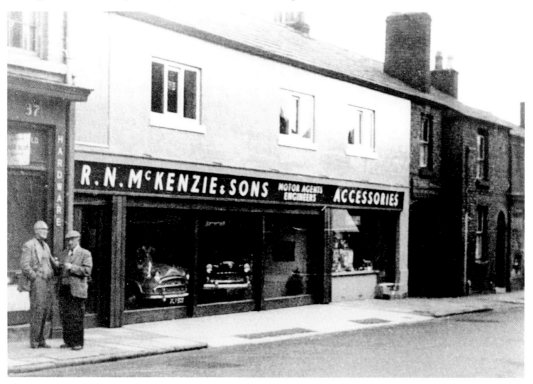

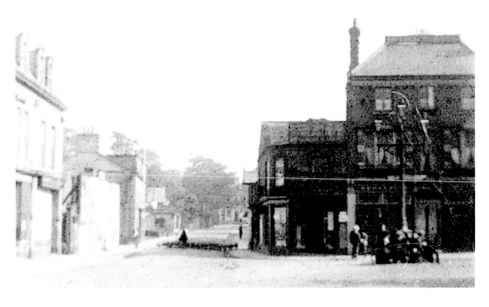

Driving Sheep along Speke Road

It has been a long, long time since sheep were seen being driven along Speke Road, but many years ago, it was a regular occurrence when the flock had to be taken to market. Although the image above is of poor quality, this image is of historic importance and had to be included.

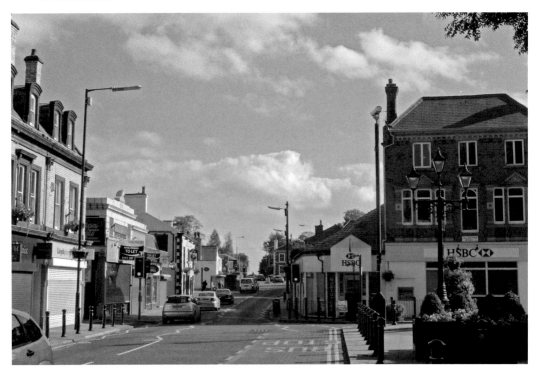

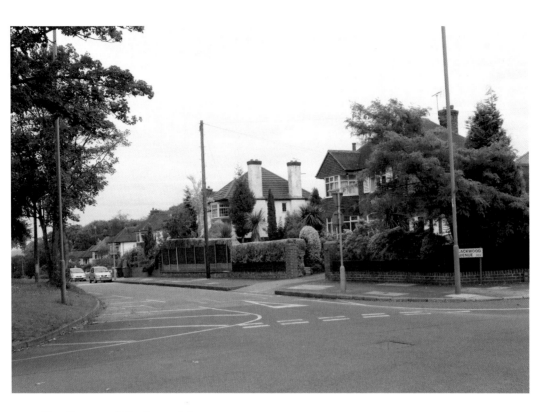

The Corner of Blackwood Avenue

Blackwood Avenue continues to remain a quiet, residential road on the edge of Woolton. The external appearance of the properties is much the same as when they were built, but there have doubtless been many changes internally. Also, the road is now a dual carriageway to take account of the increase in traffic flow since those earlier days.

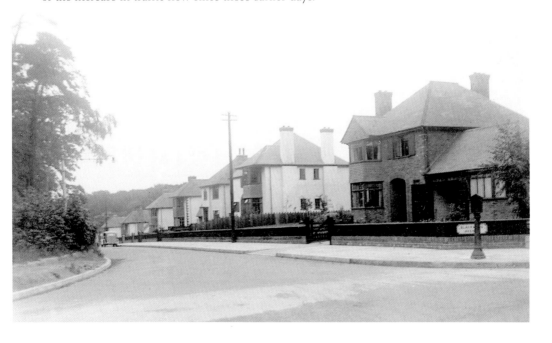

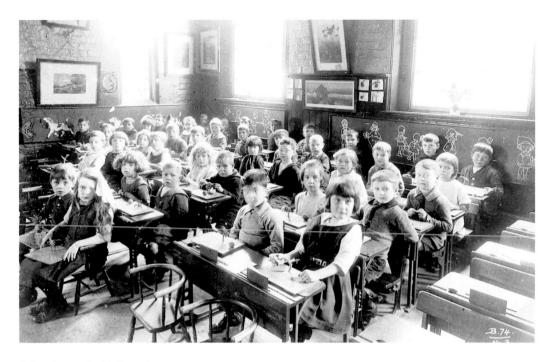

Schoolroom in St Peter's

The Education Act of 1944 once again changed the organisation of Much Woolton School, as had the earlier Education Act of 1870. The school no longer admitted pupils over the age of eleven from that time, and became a junior mixed and infants' school. In 1946, Miss Davies, who, until that time, had been headmistress of the girls school, became head of the newly designated school. As can be seen, the building serves a very different purpose today. The Simon Peter Centre, as it is now known, is a multi-purpose building and meets the needs of a range of user groups.

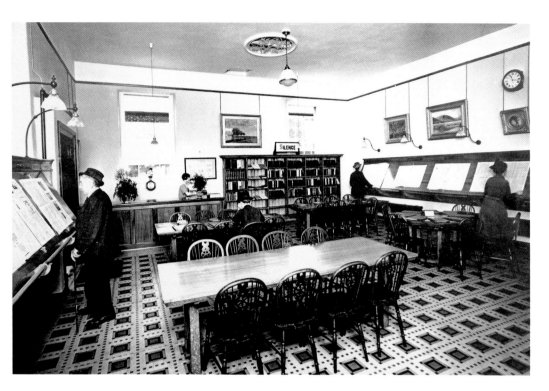

Library Reading Room

The reading room in Woolton Library was frequented by many avid readers in former times. However, the venue is just as popular today, but the multi-media resources that are now available are very different from the newspapers known to earlier generations.

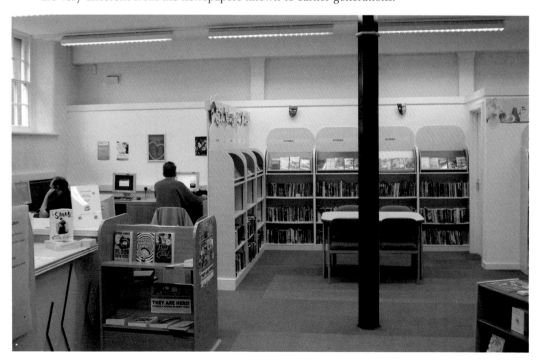

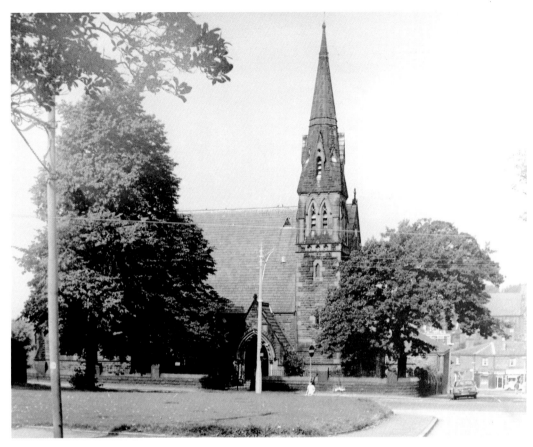

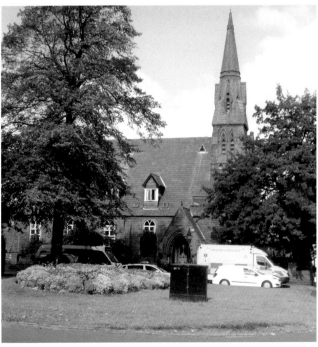

High Street Congregational Church

High Street Congregational church was built in 1864-5, and was the spiritual home of Congregationalists in the Woolton area for many years. Indeed, as early as 1822, efforts had been made to establish a Congregationalist church in Woolton, but to no avail. But then, in 1863, a second endeavour proved somewhat more successful. The building, having had many structural changes, is now the Woolton Grange Care Home.

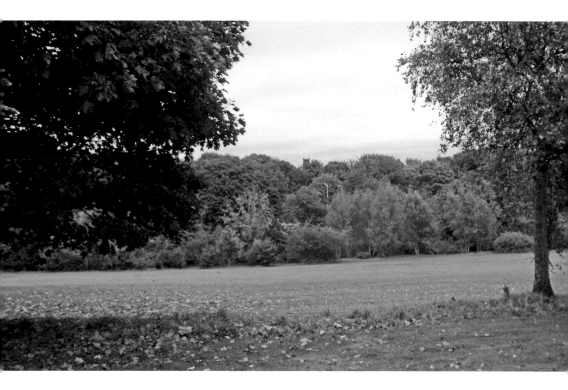

Looking towards the Bear Brand Factory

For many years the Bear Brand factory – seen on the extreme right in the earlier photograph – or Howard Ford's as it was more properly known, was one of the main employers in the Woolton area. The factory made women's nylons, and later, during the Second World War, the factory produced parachutes. The factory reverted to its normal production at the end of the war, but, due to a number of factors, the factory was closed and later demolished. The site was used to build a Tesco store.

Although the later photograph was taken from a similar vantage point to the first – Allerton Golf Course – the tower of St Peter's church is the only feature that is not now obliterated by the trees. Even Menlove Avenue, in the foreground of the earlier photograph, is now hidden from view.

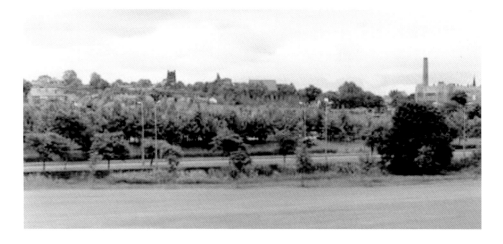

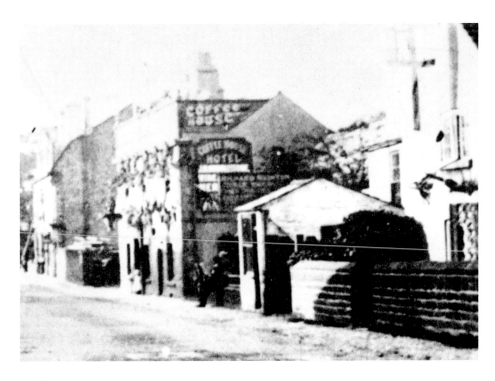

Coffee House

The Coffee House is reputed to be one of the oldest pubs, if not the oldest pub, in Liverpool. The date of the side of the wall declares that it was built in 1641.

Woolton's three-day annual festival, Woolton Green, was held each June behind the Coffee House.

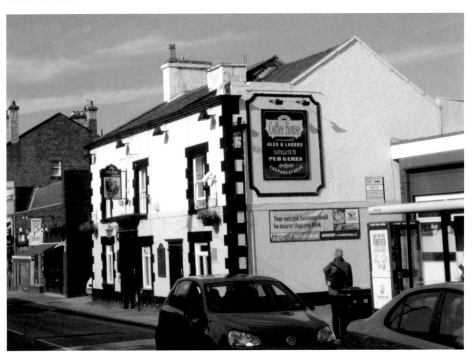

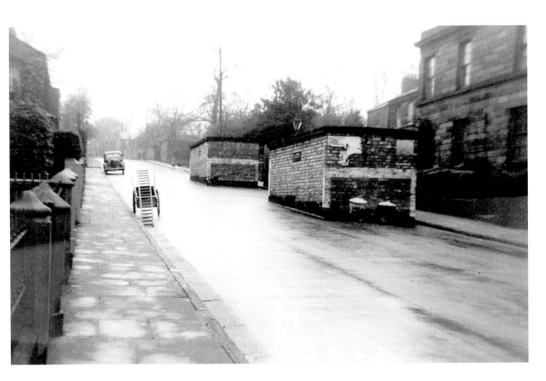

Air-Raid Shelters in Church Road
The window cleaner still did his rounds, even at the height of the Second World War, as can be seen from the air-raid shelters sited in Church Road, but Church Road presents a very different aspect today.

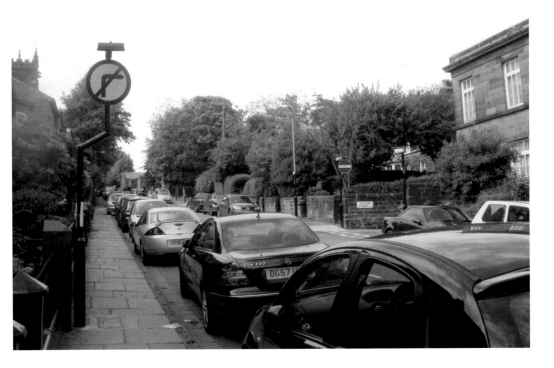

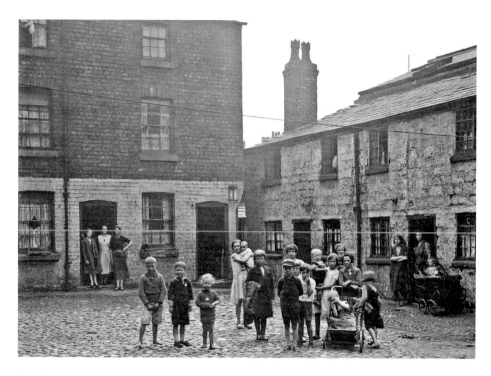

Pitt Place

Not very much remains of Pitt Place as it was shown in the earlier photograph, but it is all too easy to see the poor living conditions, which were not too uncommon in Woolton in the nineteenth century. Reports in the head teacher's notes of the time all too often record absenteeism because of children not having shoes to wear, or their parents being unable or unwilling to pay the one penny in order to attend school.

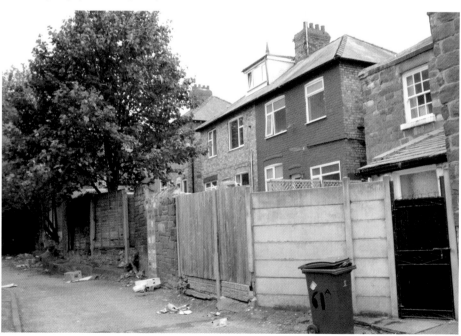

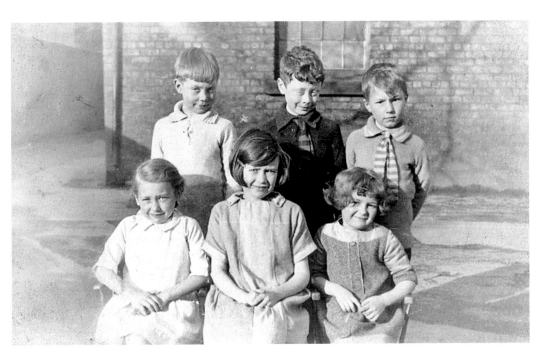

St Peter's School Playground

The playground at St Peter's is much the same today as these six youngsters will remember it. But, the school is now housed in a new building just across the road.

The inset shows the boys class, class V, of 1921.

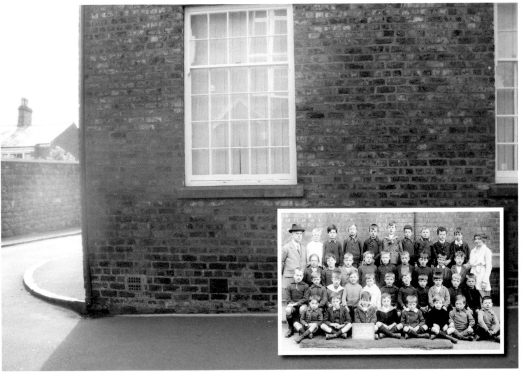

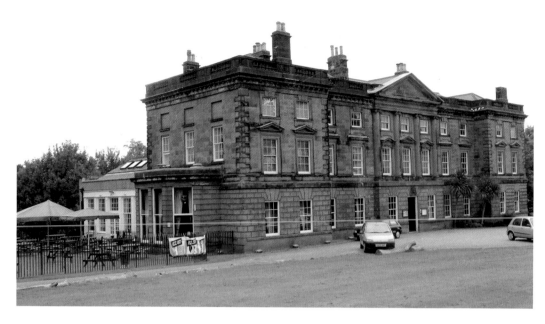

Allerton Hall

Allerton Hall is one of the finest examples of Palladian architecture in the north of England. John and James Hardman of Rochdale bought the estate in 1736 and probably started building work shortly after that time. The work was completed in 1810-12, in the original Italian style, by William Roscoe. Best known for his work as an anti-slave-trade campaigner, Roscoe was also a botanist, poet, historian and merchant. Unfortunately, due to bankruptcy, he was forced to sell the estate in 1816. Subsequently, the estate was owned by the Clarke family, who later bequeathed the hall and the surrounding park, known as Clarke Gardens, to the city of Liverpool in 1927. The hall was damaged by fire in the mid-1990s but has since been refurbished. The property is now a popular event venue and meeting place known as The Pub in the Park.

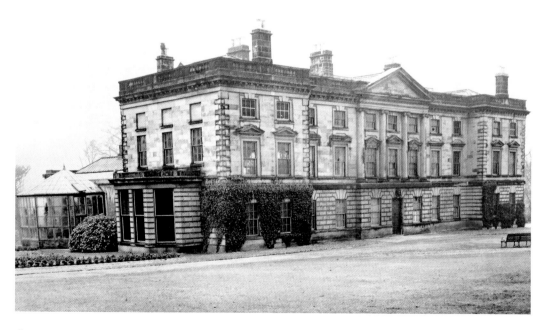

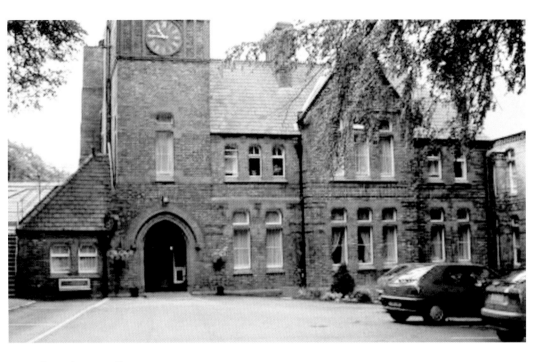

Convalescent Home

The Gothic-revival hospital was built in 1869, and several additions were later made. During the First World War, the building was known as the Woolton Military Auxiliary Hospital. For a time during the Second World War, the building was used by the Royal Navy. It has also been used as a training school for nurses. Today, Woolton Manor Care Home is a care home with nursing. It is privately owned.

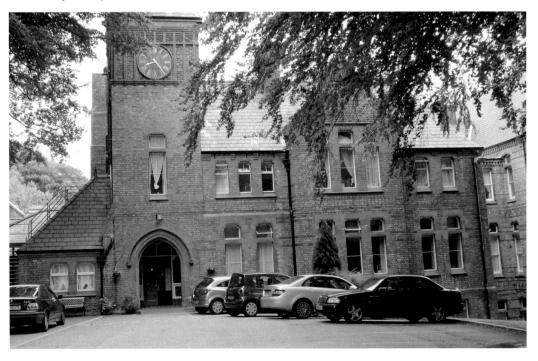

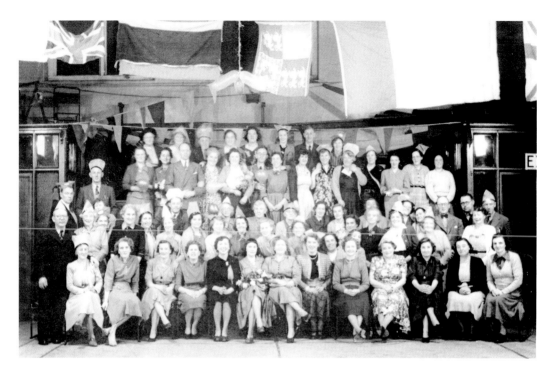

St Peter's Church Hall

The church hall at St Peter's was, and still is, well used; many of the parish's social activities take place in the hall. Also, when the junior school was just across the playground, assemblies were held here and also the school's annual Nativity pageant. The group seen in the earlier photograph is the Adult Fellowship Group, who met on a regular basis for many years. Other notable events include Paul McCartney's first meeting with John Lennon.

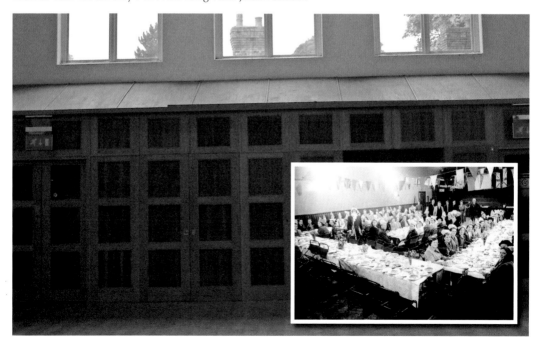

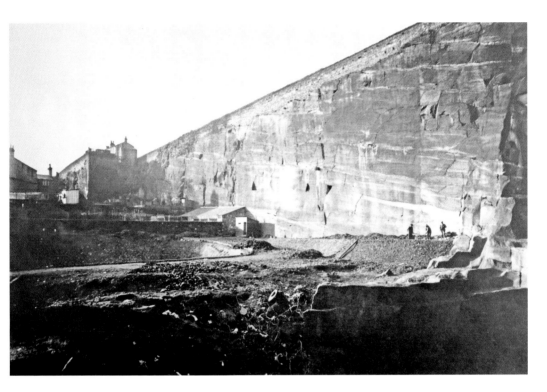

Woolton Quarry

Since the quarry closed, shortly after the completion of Liverpool's Anglican cathedral, the site has had many uses, including serving as a council rubbish tip and later as a tyre disposal area. However, following a major fire, that particular enterprise came to an end.

Although some distance away from the quarries, which can just be seen towards the back of the more recent photograph and below the houses, the new Tesco store is one of the main retail centres in the village. The superstore was built on land formerly occupied by the Bear Brand factory.

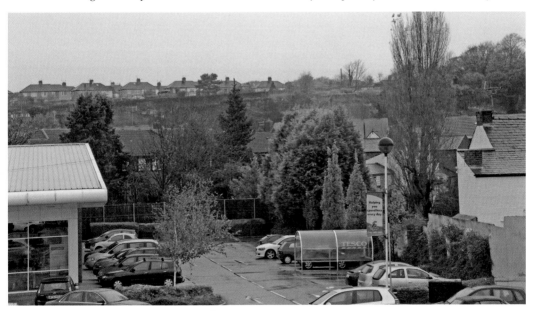

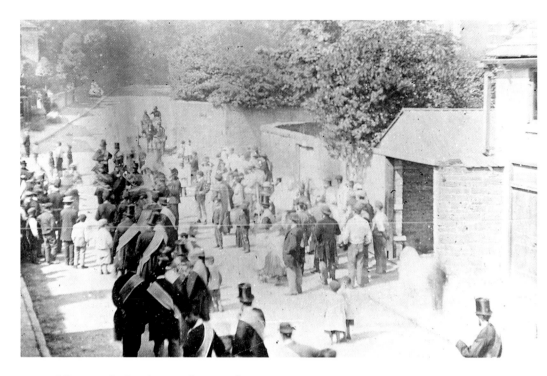

Assembling Ready for the Woolton Walk

Walks of Witness were a common feature in many villages throughout Lancashire and Cheshire. Villagers and members of various clubs and other institutions are seen assembling here for the annual walk.

Out Lane, seen leading off to the right, is one of the oldest lanes in Liverpool, but in those days, Woolton was still independent of Liverpool.

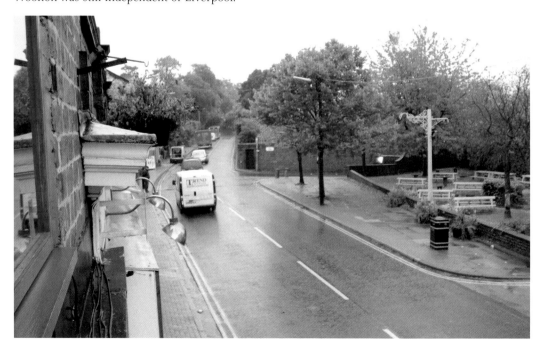

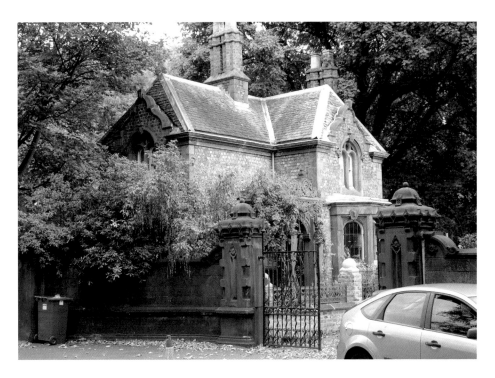

Camp Hill Lodge

Hillfoot Road, from where these photographs were taken, runs along the bottom edge of Camp Hill, and Camp Hill Lodge is built where there is access to Camp Hill itself. Camp Hill, which is the location of an Iron Age fort, has, over the centuries, had a number of owners. The area is now part of Woolton Wood.

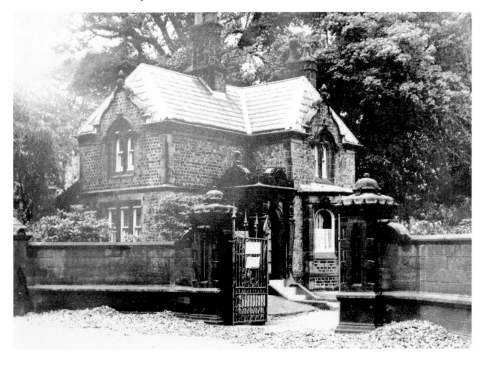

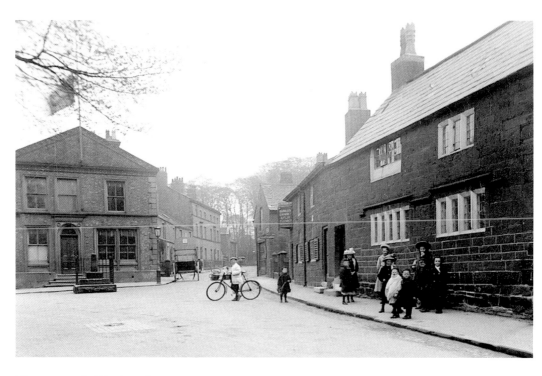

View towards Woolton Street

The bicycle painted on the road now is not so very different, in some respects, from the one in the original photograph.

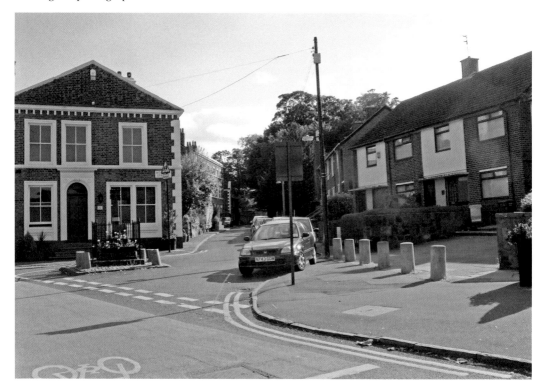

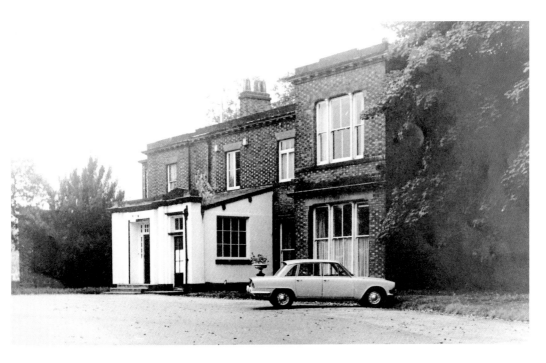

Woolton Golf Club

The history of Woolton Golf Club is rich and proud. It was in 1899 that Lewis Samuel Cohen, a director of Lewis's Limited, purchased Doe Park, an estate of some 45,428 acres. His intention was to create a golf course. The course was ready for play towards the end of 1900. At that time, the club boasted nine holes, but in 1906, land to the north side of Speke Road was purchased, enabling the course to be extended to eighteen holes. The golf club is now established as one of the premier clubs in the north-west of England.

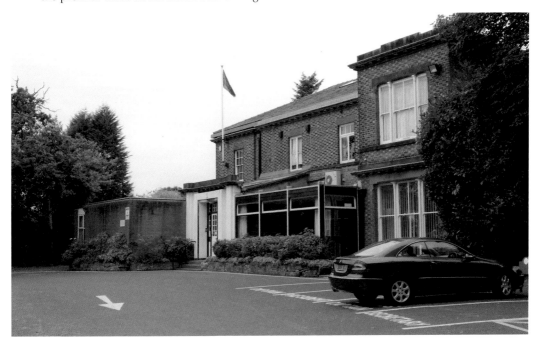

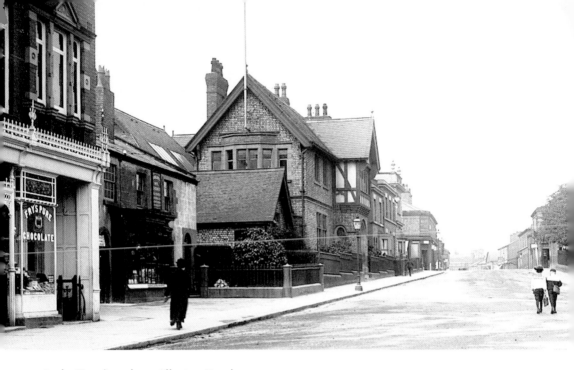

Early Morning along Allerton Road

In many respects, the view along Allerton Road today is very similar to what it was at the beginning of the twentieth century; many of the buildings are still there, but also present is the vehicular traffic that certainly wasn't present then!

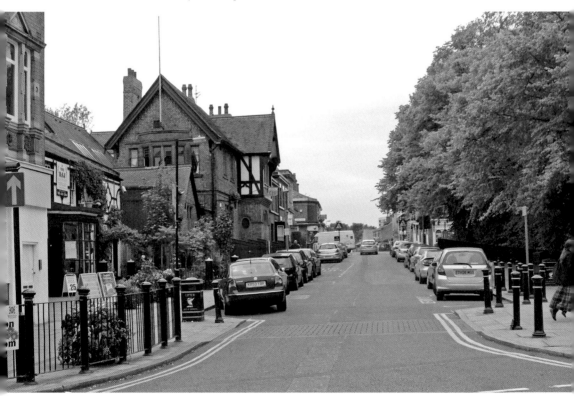

The Mechanics Institute

The Mechanics Institute, or the 'Mechanics' as it was known locally, first opened its doors in 1849 and continued, in one form or another, until 1928. During that time, it was used for many purposes – Band of Hope rallies, spelling bees, schoolroom, mutual improvement meetings, police court, political meetings, and a large number of other functions. Indeed, in the severe winter of 1874, when many local workmen couldn't find gainful employment, the 'Mechanics' was used as a soup kitchen. During an eleven-day period, in excess of 400 persons were fed, twice every day, with a bowl of soup and a slice of bread.

Looking towards St Peter's

Taken from Woolton Wood, the view towards St Peter's shows the same houses now along High Street as were built many years ago. But, over the years, the landscape has changed somewhat due to the phenomenal growth of trees in the area.

Pudding Bag Square

Ashton Square – named after Nicholas Ashton, one of the former owners of Woolton Hall – was previously called Pudding Bag Square. That name came about because many of the village's black puddings were made in that vicinity. The hall's butler lived in the Fabric Cottage near to Ashton Square, and estate workers and grooms lived in the square itself. Today, the square is at the centre of a quiet residential area, and, to outward appearances, looks very much as it did all those years ago.

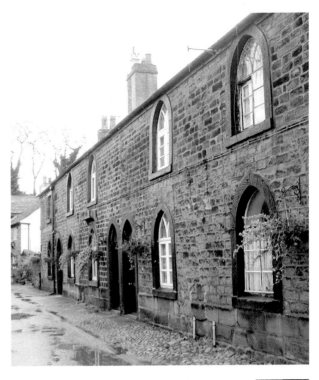

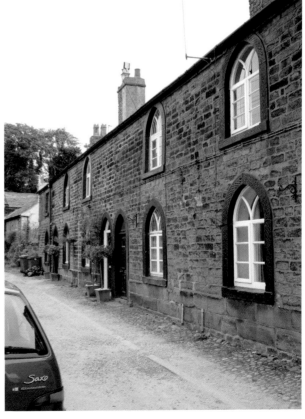

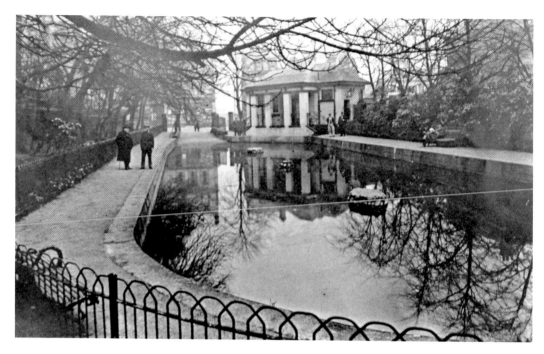

Lodes Pond

A minute from the local board of Much Woolton records the fact that ' ... the Marquis of Salisbury gave and granted to the local board the land known as the Lodes in the township of Much Woolton, as the same was then fenced in by a wall and iron railings and partly used as a watering place for cattle and partly as a shrubbery and pleasure ground upon trust that the local board and their successors should for ever maintain and keep the premises as a watering place for cattle and shrubbery and pleasure ground for the use and benefit of the inhabitants of the township of Much Woolton.' The site of Lodes Pond is now a car park!

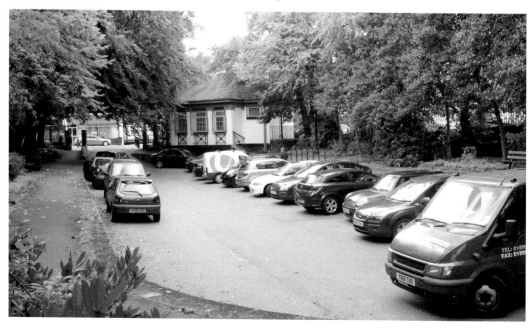

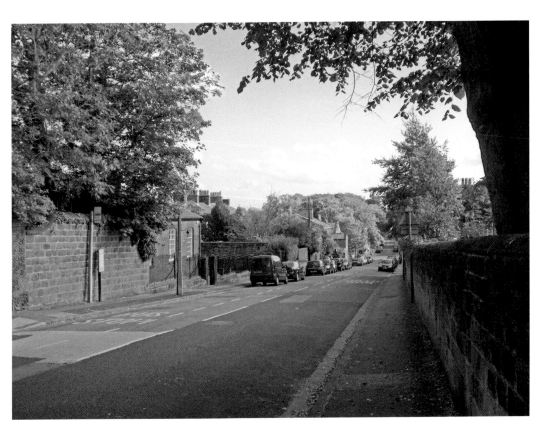

Looking down Church Road

Church Road is just as busy now as it has been for many years. But, even before the advent of motorised traffic, it was always a particularly busy road, with carriages making their way either to St Peter's or one of the grand properties towards Woolton Park. And today, because of the Beatles' connection with the area, coaches, filled with eager tourists, can regularly be seen plying up and down the road.

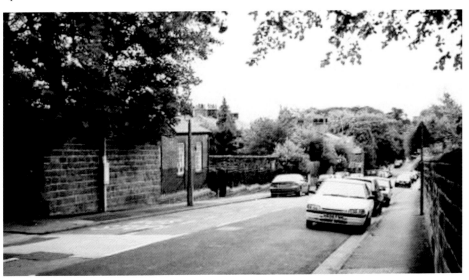

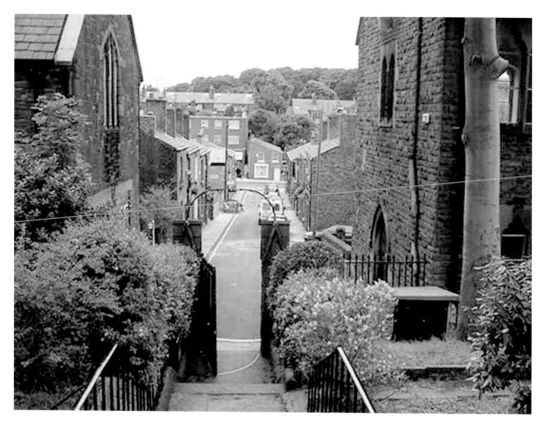

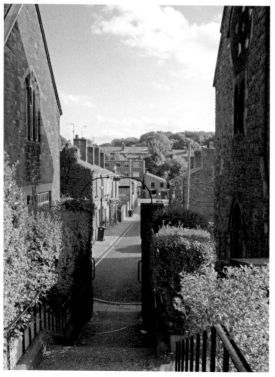

Looking out to St Mary's Street
Looking from the steps of St Mary's church, the view today is much the same as it was some fifty or sixty years ago. The Mechanics Institute building is the prominent building to the left, whereas the church school can be seen on the right. It was in 1869 that the school was opened by Father John Placid O'Brien. In those early days, children brought pennies to school to pay for their education. Also, resources, such as slates and books, were usually supplied by the children's parents.

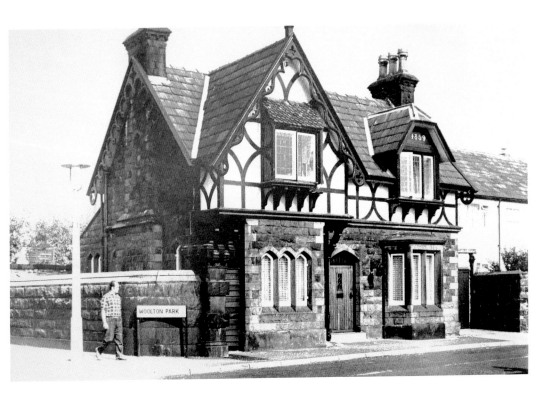

Riffel Lodge

Riffel Lodge was built in 1859, as the date on the house clearly shows. Serving as the entrance to the Riffel estate, the lodge is a two-storey cottage, built of local sandstone. The distinctive style of the lodge is mock Tudor, with a half-timbered upper storey, as was the vogue in the mid-nineteenth century.

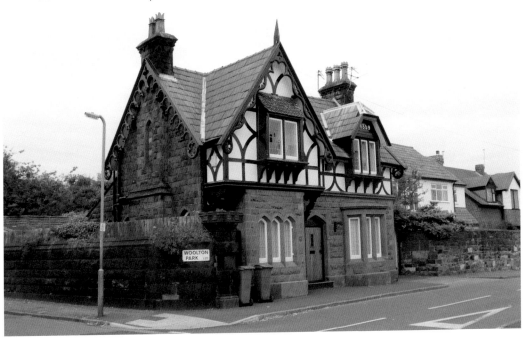

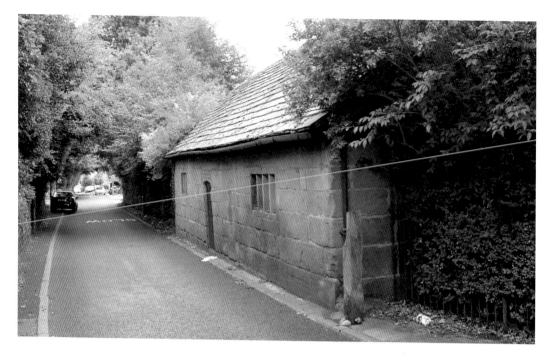

The Old School

Many myths and legends are told about the Old School in School Lane – some of which are difficult to substantiate. What cannot be disputed, however, is the fact that the school building is the oldest of its type in Lancashire. (Lancashire, prior to the boundary changes of 1974.) The inscription in the sandstone lintel suggests that the school was built in 1610, but registers at All Saints' church in Childwall date the building at 1597. There is even some evidence stating that a building of some description was used for educational purposes as early as 1575. Fittingly, the building is now home to a nursery, serving the earliest educational needs of Woolton's next and future generations.

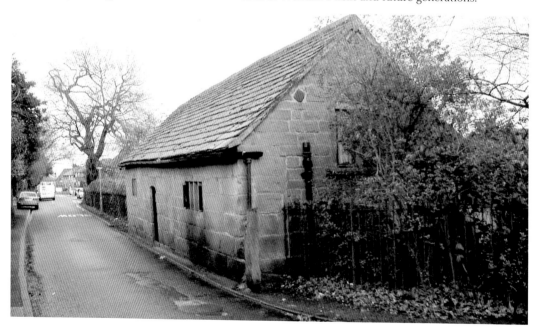

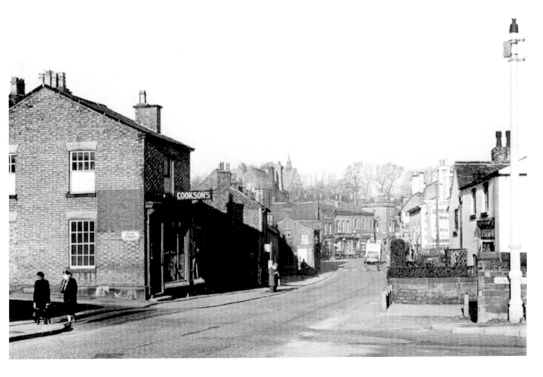

A View along Woolton Street

Woolton Street, perhaps the main 'through road' of the village, has been a feature of the village for centuries. Cattle, sheep and pigs were once driven along Woolton Street, either on their way to market, or the nearby abattoir. Today, the scene is very different, and, more often than not, there are traffic jams along the narrow road.

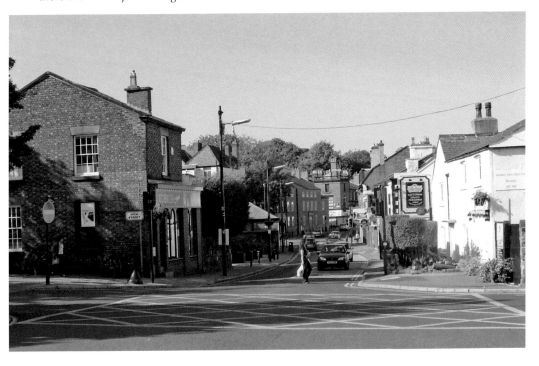

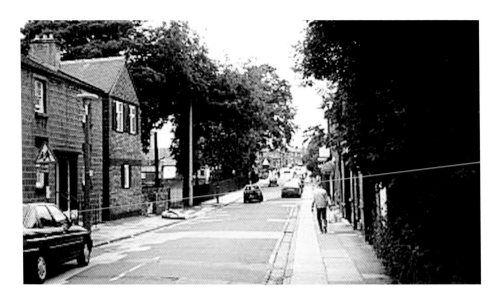

Quarry Street

The name says it all! Quarry Street was, and is, one of the main residential roads in Woolton village. It was once the home to many of the workers at the various quarries in and around the village – perhaps most notably, the north and south quarries further along the street, where the sandstone for Liverpool's Anglican cathedral was quarried.

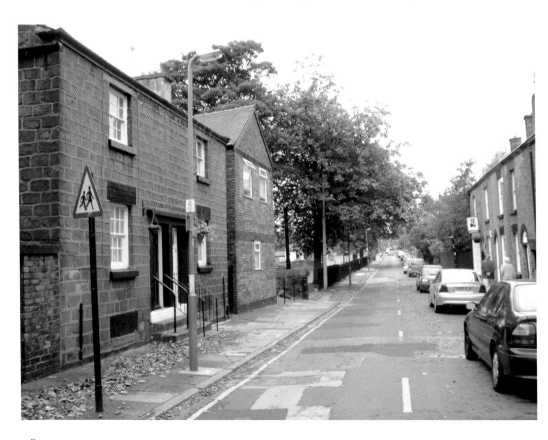

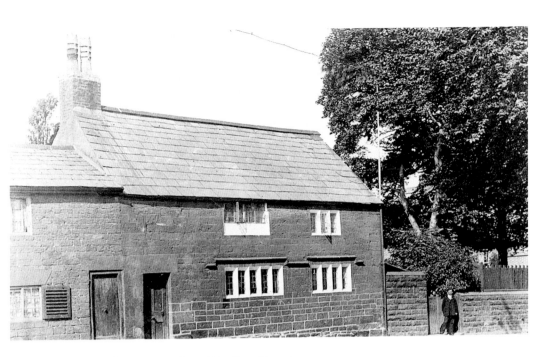

Outside the First House along Woolton Street

Woolton Street, as its name suggests, is one of the oldest streets in the village. High Street can be seen on the right-hand side of the photographs. The land immediately behind Woolton Street is Woolton Wood. The street is still primarily residential, but the man standing in the earlier photograph might find it difficult to recognise; the building next to him was home of the first post office in Woolton, which was opened in 1826. The building was demolished in 1952.

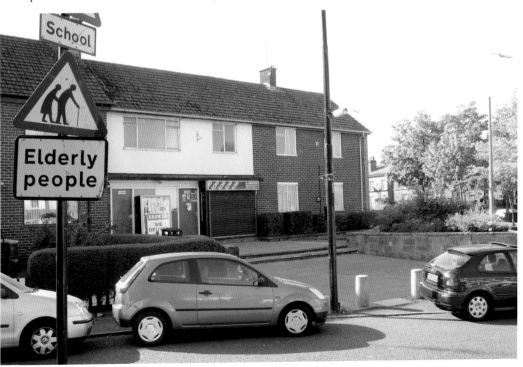

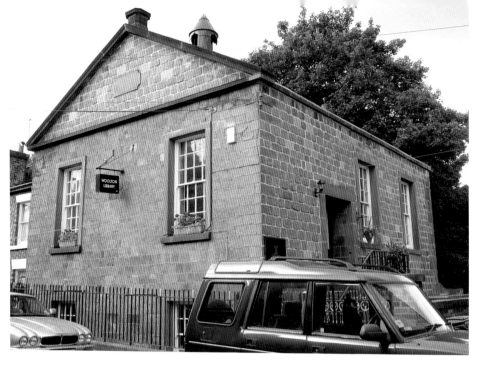

The Library

The library in Woolton was built originally as a Wesleyan chapel in 1834. In fact, it was the first Wesleyan chapel to be built in the village. When St James' church opened, the chapel was used as a Wesleyan day school but subsequently became the home of Woolton Library.

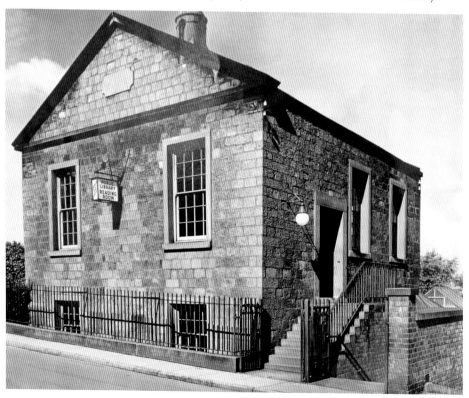

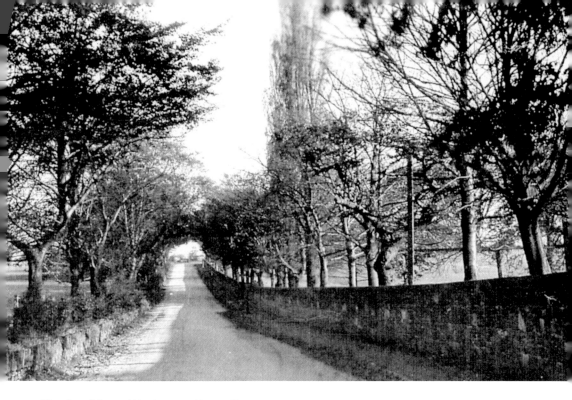

The Road from Woolton to Hunts Cross

The road from Woolton to Hunts Cross cuts its route right through the links of the prestigious Woolton Golf Club, and it still does, and further, the road is still fairly peaceful – most of the time!

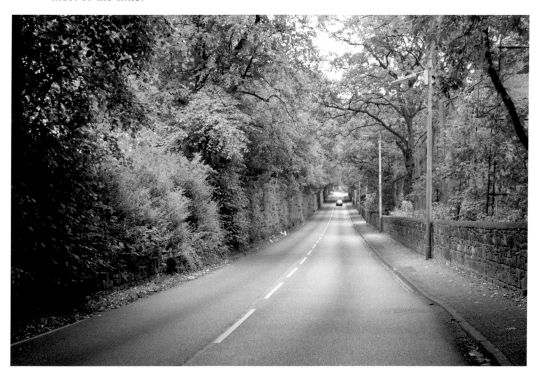

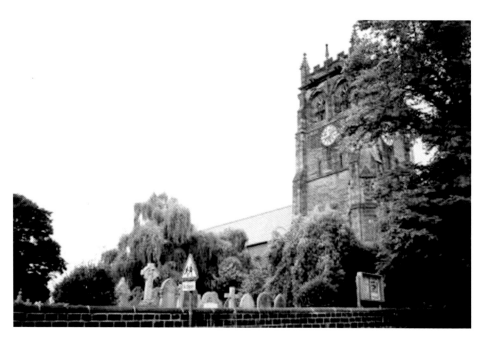

St Peter's Church

The first Church of St Peter to be built in Woolton was consecrated in 1826, the first incumbent being the Revd Robert Leicester. At that time, and until 1865, Woolton remained as a chapelry of All Saints in Childwall. With the steady rise in population in the village, and the subsequent rise in congregations, it was considered that a larger church should be built. The foundation stone of the present Church of St Peter was laid in 1886, and the church opened during the following year. Like so many other buildings in the area, the Church of St Peter was built from sandstone quarried in Woolton.

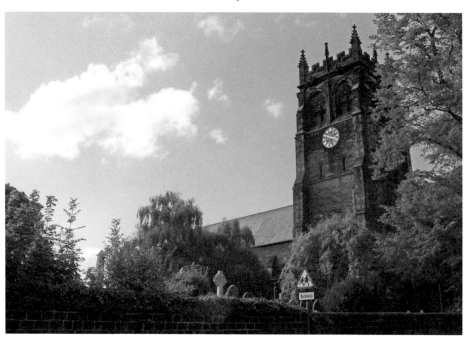

St Mary's Church from the Road
In 1766, Dom Bernard Catterall, chaplain to the widowed Viscountess Molyneux of Croxteth, was given 12 acres down Watergate Lane to provide for a mission to be established. Previously, the mission had been served from Woolton Hall. St Bennet's Priory was built, but, with the influx of large numbers of immigrants in the nineteenth century, the congregations swelled. The priory was twice enlarged, but, ultimately, it was decided that a new church must be built. St Mary's was built in 1860 and a linked presbytery added in 1870.

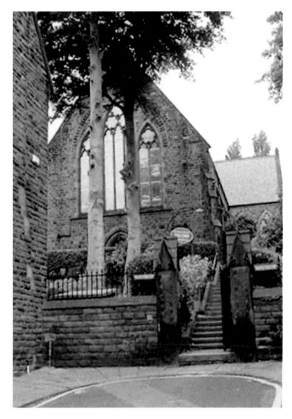

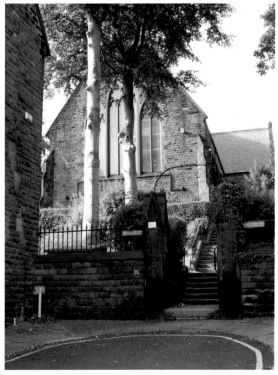

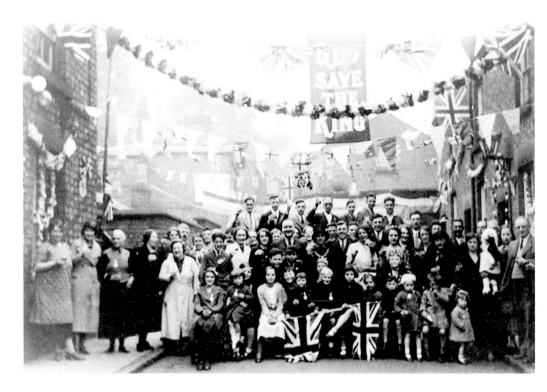

Rushton Place

In 1937, friends and neighbours from in and around Rushton Place celebrated the coronation of King George VI in some considerable style, as was the custom in those days. Today, Rushton Place is a quiet, residential road in the heart of Woolton village.

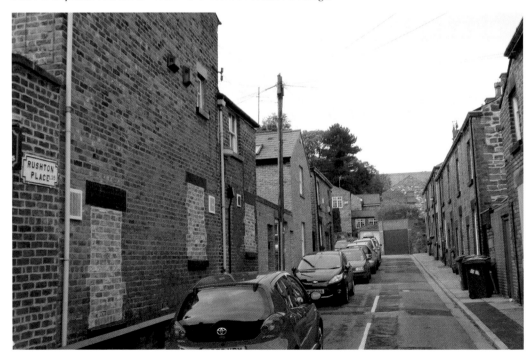

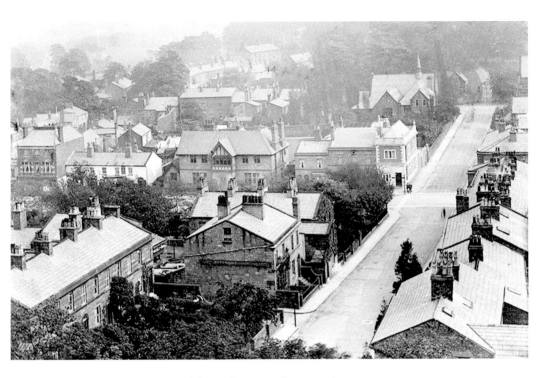

Looking down Church Road from the Top of St Peter's

Since 1887, the tower at St Peter's church has dominated the skyline in Woolton. This view is looking down Church Road. The village hall can be seen in the centre of the earlier photograph, but the view in the later shot is obscured by foliage around Lodes Pond.

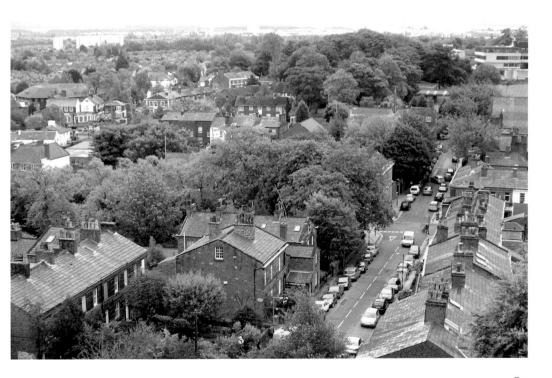

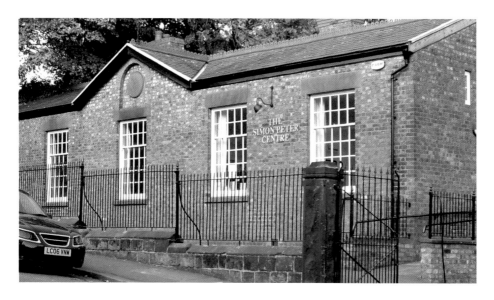

The Boys School

Before the Education Act of 1870, a number of charitable organisations were the main providers of education. The building, which is now known as the Simon Peter Centre, was previously the Church of England junior school, and before that, it was known as the Boys School. The school was built on enclosed land on the common, adjacent to the workhouse. It is believed that the school became established in 1820 and that the school itself was opened in 1821, although the building work was not completed until 1823. Prior to that date, part of the workhouse was used to educate the girls of the village – the boys were still being educated in the old school in School Lane. But, sometime later, provision was made for an infants' department. The building was completed in 1848, and at that time, the girls school was transferred there; the boys left the School Lane building and moved to what was to become the boys school.

The Simon Peter Centre, as it is now known, is a multi-purpose building, having been completely redesigned and refurbished following the opening of the new Bishop Martin Church of England Primary School.

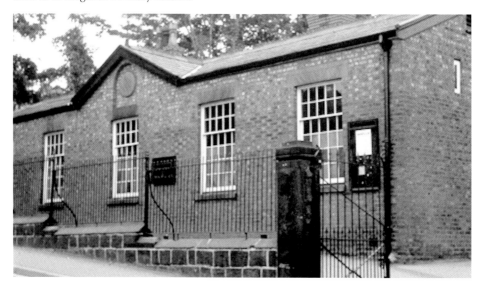

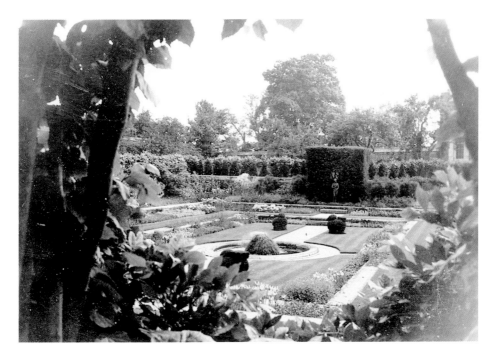

Topiary at Reynolds Park

Following the addition of Dove Park in 1907, Reynolds Park today lies within the boundaries of James Reynolds' 1929 bequest. One of the most significant features of the park is a walled garden. In all probability, this would have been a kitchen garden, servicing the fresh produce needs of the mansion house.

Today, the park is particularly known for summer bedding plants, displays of various dahlias and its herbaceous borders. The topiary garden can still be seen, and there is now a butterfly garden, which didn't feature during James Reynolds' time. It is significant to note that there is also a major topiary at Levens Hall, another one of the estates owned by James Reynolds.

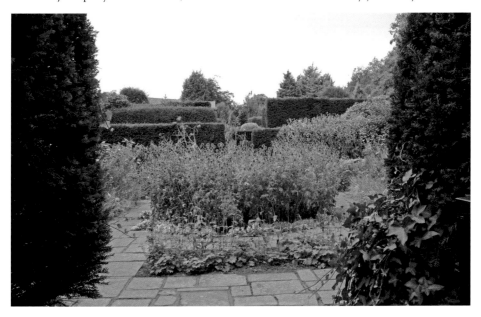

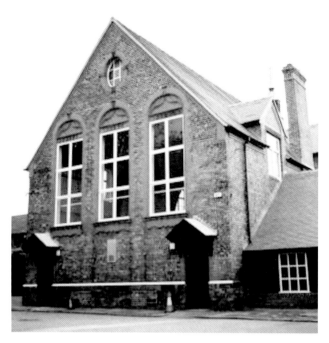

St Peter's Church Hall

No book about Woolton would ever be complete without making reference to St Peter's church hall. It was on the evening of Saturday 6 July 1957, more than fifty years ago now, that members of the Quarrymen Skiffle Group were waiting to take to the stage. A mutual friend introduced the teenage Paul McCartney to John Lennon and other members of the group. It is recorded that the meeting lasted somewhat less than half an hour, but, during that brief period, Paul impressed the Quarrymen by showing them how to tune their instruments and demonstrating his impressive musical knowledge and ability. A few days later, Paul accepted an invitation to become a member of the group. John Lennon is reputed to have said 'that was the day, the day I met Paul, that it started moving'.

Although the photographs are separated by many years, it appears that St Peter's are still making use of the same traffic cones!

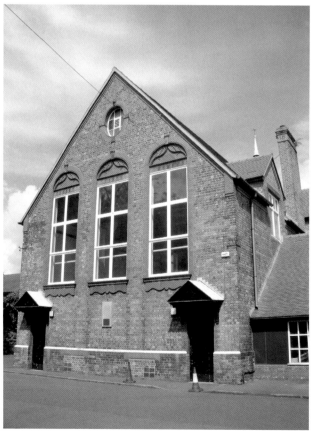

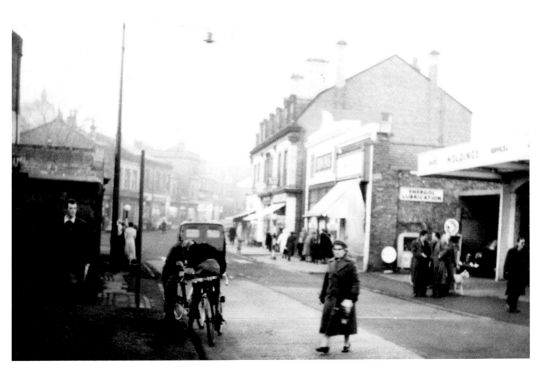

The Heart of Woolton Village

Always at the heart of village life, this is one of its busiest streets. The needs of the shoppers have changed somewhat since the early '50s, and so indeed have the shops, but the street itself is just as busy as ever.

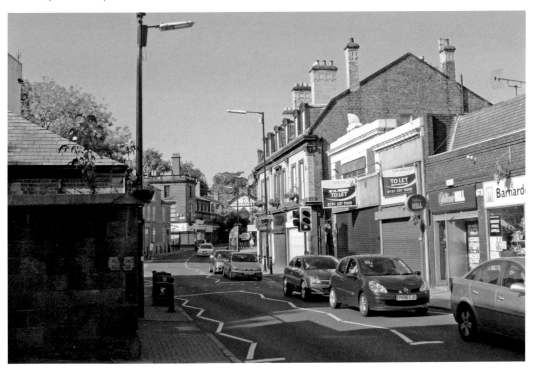

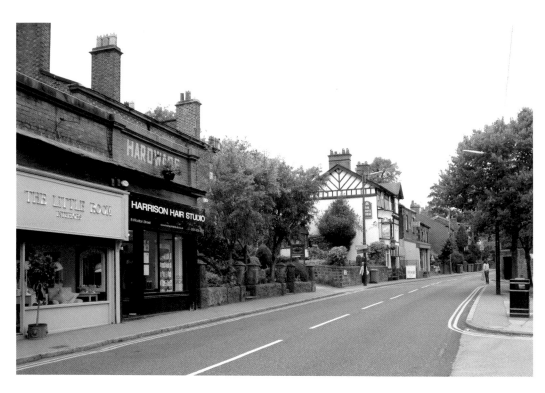

The White Horse in Acrefield Road

Woolton has always been blessed with many pubs, and still is; one of the oldest and still one of the favourite 'watering holes' for many Wooltonians is the White Horse in Acrefield Road. The image below is very old and therefore can't be reproduced at a high quailty.

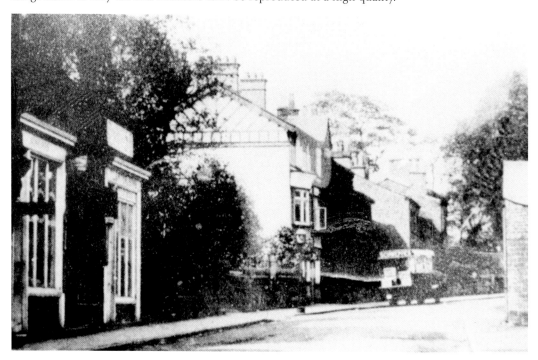

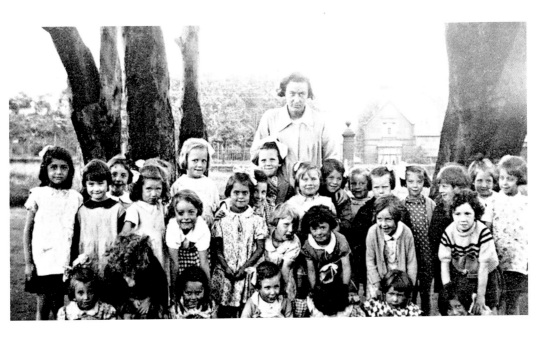

Girls from Much Woolton School

Mrs Learoyd, who became headmistress in the girls school in 1904, introduced 'botanical walks', which were usually walks through the nearby Woolton Wood to study spring growth, although other venues were sometimes visited. Just two years before Mrs Learoyd was appointed as headmistress, term time was shortened and the summer holidays were extended to five weeks. This additional holiday was at the special request of King Edward VII to commemorate his coronation.

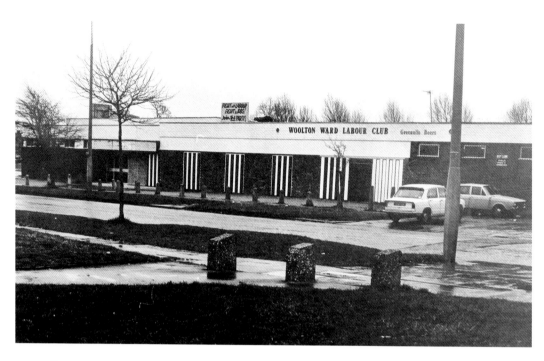

Lee Valley Millennium Centre

Formerly the Woolton Ward Labour Club, the building was completely demolished and a new multi-purpose building commissioned. The Lee Valley Millennium Centre was opened by the Duke of Gloucester on 2 May 2001. The centre has been designed to offer an environment conducive to education and other cultural pursuits, having a wide range of multimedia facilities and a library.

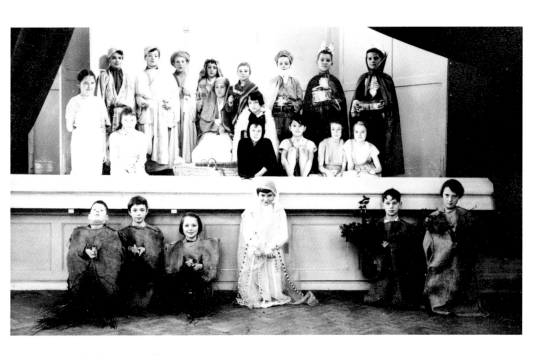

St Peter's Church Hall

St Peter's church hall has been the focus of many activities over the years. When the junior school was housed just across the playground, the hall was used for school assemblies and also the Christmas Nativity, as can be seen in the earlier photograph. Parish functions were, however, the main activities that the hall hosted. Following the church fête held in July 1957, a skiffle group called the Quarrymen appeared on the stage. And that day, in that church hall, was the day that Paul McCartney met John Lennon. The stage is now in storage for safe keeping, and part is held in a museum in Liverpool.

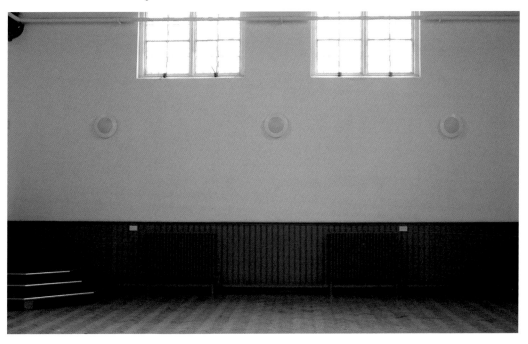

Outside Woolton Cinema

It was in the winter of 1927/28 that the cinema first opened its doors to the public. The proprietors of the proposed development, The Woolton Picture House Co. Ltd, were given permission to construct the building on the proviso that the work would be completed within a period of six months. The architect, Lionel A. G. Pritchard, being well known for cinema design, was given a difficult brief, in that the proposed cinema was close to residential housing and was also to be on a steep hill. However, all of the difficulties were overcome, and the cinema was opened on time.

The cinema closed on 3 September 2006 following the death of the owner. It reopened on 29 March 2007 and is still going strong!

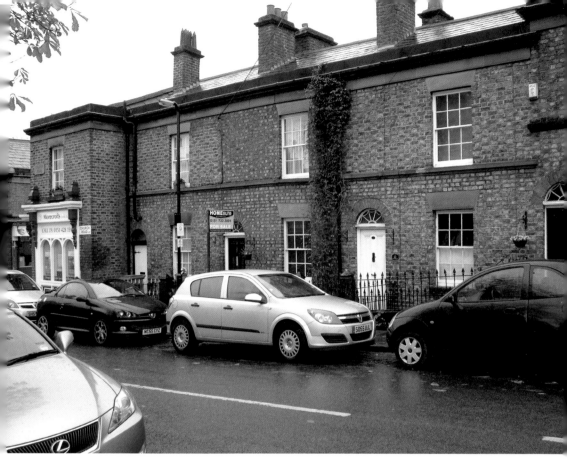

The Rose Queen Festival

The Rose Queen was always carried to the fête in style, as you can see from the horse-drawn carriage in the picture below. Crowds of people are watching the procession down the street. The modern view of Church Street shows how much the modern view has changed, with residents' cars lining the pavements today.

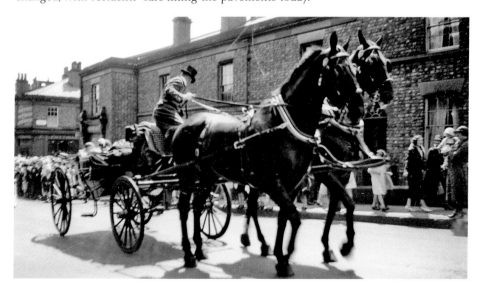

Acknowledgements

I would like to record my thanks to Peter Moss, gardener at Reynolds Park; Mrs Stern of Riffel Lodge; Brian Seddon, for allowing me to use some of his photographs of the village; for the staff at Woolton Library, especially June, for allowing me access to and use of the files on the village of Woolton; the staff at Allerton Glass and Glazing; the management of Woolton Manor Care Home, for allowing me to take photographs in the grounds; John Banks and Mrs Grace Hosker. It would be remiss to end without giving special thanks to Graham Paisley, verger at St Peter's, for his time and invaluable help.

Finally, whilst I have made every effort to ensure that the notes in this book are factually correct, any errors or inaccuracies are mine alone.